HAWORTH
OXENHOPE & STANBURY
From Old Photographs
Volume 1 Domestic & Social Life

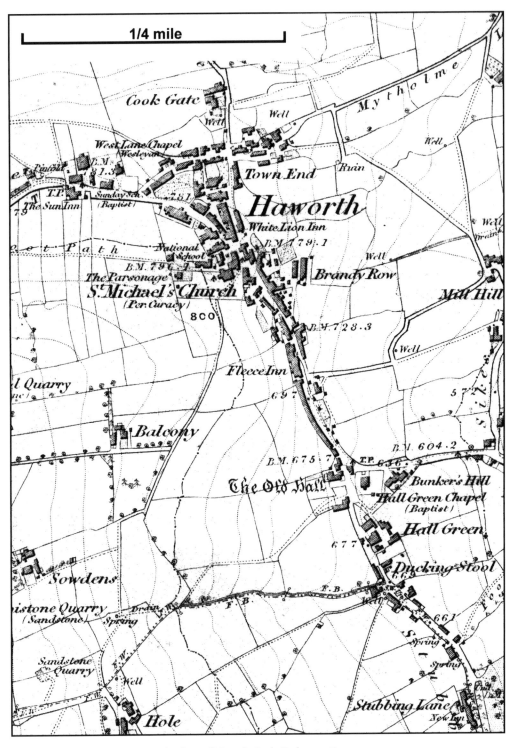

Haworth village in 1847. From the first edition six-inch Ordnance Survey map.

HAWORTH
OXENHOPE & STANBURY
From Old Photographs
Volume 1 Domestic & Social Life

STEVEN WOOD

AMBERLEY

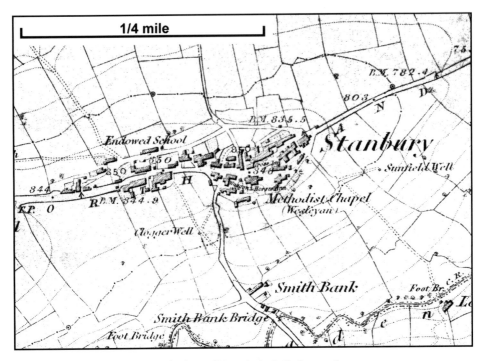

Stanbury village in 1847. From the first edition six-inch Ordnance Survey map.

For Lynn

First published 2011

Amberley Publishing
The Hill, Stroud
Gloucestershire, GL5 4EP

www.amberleybooks.com

Copyright © Steven Wood, 2011

The right of Steven Wood to be identified as the Author
of this work has been asserted in accordance with the
Copyrights, Designs and Patents Act 1988.

British Library Cataloguing in Publication Data.
A catalogue record for this book is available from the British Library.

ISBN 978 1 4456 0368 1

Typesetting and Origination by Amberley Publishing.
Printed in Great Britain.

Contents

Acknowledgments 6

Introduction 7

1. General and Street Views 11

2. Houses 55

3. Schools 80

4. Churches 88

5. Leisure 128

Acknowledgements

This book could not have been produced without the generosity of the many people who have lent me their collections of photographs and provided information over the past twenty odd years. Not all their names are known to me, but I am grateful to them all. Here I might mention the names of Eric Bates, Jonas Bradley (who died before I was born but has come to seem almost a collaborator), Rita Brearley, Molly Davidson, Ann Dransfield, John Farrar, George Feather, Fr. Ben Griffiths, Rob Grillo, Janet Holdsworth, Hazel Holmes, Harold Horsman, Jack Laycock, John and Barbara Laycock, Norma Mackrell, Smith Midgley, Ian Palmer, Mary Preston, Andrew Schofield, Irene Shackleton, Flossie Waddington, Mrs P. White and Graham & Stewart Wright. David Smith deserves special mention. Without his generosity this book would have been a very different thing. The institutions that have contributed are the Brontë Parsonage Museum, Cliffe Castle Museum, the Civic Trust and Keighley Local Studies Library. The maps are extracted from Sheets 200 and 215 of the first edition six-inch Ordnance Survey of 1852, surveyed in 1847.

There are, no doubt, names missing that should be here – my apologies to them.

The staff of Keighley Local Studies Library have been encouraging and helping me for over twenty years. My thanks to them all.

The text would have been poorer had I not been able to draw on the work of fellow historians Michael Baumber, Robin Greenwood, Reg Hindley and the late Dennis Thompson. Ann Dinsdale kindly read the text in draft, and has helped in too many ways to mention over the years. David Smith also read the text and suggested many improvements.

For all remaining errors, I am solely responsible.

My wife, Lynn Wood, read the first draft and eliminated many errors of various sorts. For her tolerance and support over the years, I would like to dedicate this book to her.

Introduction

Haworth, Oxenhope and Stanbury From Old Photographs aims to provide a comprehensive view of this fascinating Pennine settlement. A total of 600 old photographs will cover most aspects of the township. The first 300, in this volume, look at domestic and social life. The remaining 300 photographs will be published in a second volume, which will cover trade and industry. These categories are very broad, and thus each volume is divided into sections. This book has sections covering general and street views, houses, schools, churches and leisure. These will be examined in more detail below. The second book will embrace shops, pubs, farms, quarries, textiles (with a whole section on Timmy Feather, the last of the handloom weavers), reservoirs, gas, roads and transport.

The various terms used for different parts of the township can be confusing and it will be as well to explain them at the outset.

The Township of Haworth was an administrative area that covered over 8,000 acres (about 12½ square miles or 32 square kilometres) of the Yorkshire Pennines. It was divided into four hamlets for local government purposes. These hamlets must not be thought of as tiny settlements, but rather as large areas of land with more or less settlement within them. The four hamlets were Haworth, Stanbury, Near Oxenhope and Far Oxenhope. These divisions had been established by 1200.

Up to the mid-nineteenth century, the township was administered by the manor and the church. The manor courts and the church vestry between them dealt with the day-to-day running of the area. Around 1850, most of the local government functions were taken on by Local Boards of Health, and later by Urban District Councils.

Manor: The manorial history of Haworth is very complicated and only a brief summary need be given here. After the Norman Conquest, the whole of Haworth formed part of the manor of Bradford in the Honour of Pontefract. This was held by the de Lacy family. It is important to note that the de Lacys also held the Honour of Clitheroe, and that Haworth and Stanbury lay on the medieval road, Clitheroegate, which connected the two. By the end of the fifteenth century, Haworth township was divided between three manors. Two were the manors of Haworth and Oxenhope. The 'manor of Stanbury' is sometimes referred to in the records but had no real existence. Stanbury was held in demesne – that is, it remained part of the manor of Bradford. Haworth Manor is the only one which has left records later than the fourteenth century. There are surviving court records from 1581 to 1904.

Church: Until the middle of the nineteenth century, the Township or Chapelry of Haworth formed part of the large Parish of Bradford in the Diocese of Ripon. Oxenhope became a separate parish in 1847. Haworth and Stanbury became the

Parish of Haworth in 1864, although the rector did not take control of his new parish until 1867.

Local Boards: In 1850 the General Board of Health sent Benjamin Herschel Babbage to Haworth to report on its sanitary condition. This was sufficiently foul to justify the establishment of a Local Board of Health for Haworth in 1851. In 1853 a small part of Near Oxenhope Hamlet was added to the Local Board area. It was in this part of the Local Board area that Coldshaw was built in the 1880s. One result of this history is that a part of what is always thought of as Haworth is actually in the Parish (and Manor) of Oxenhope. For a distance of a quarter of a mile the west side of Sun Street is in the Parish of Oxenhope whilst the east side is in the Parish of Haworth. One can still hear stories of people who wanted to be married in Haworth parish church going to live with relatives on the other side of the street to qualify.

After the Haworth Local Board area was finally defined in 1853 Stanbury and the rest of Oxenhope were left to be dealt with. A Haworth Township Local Board was set up to cover these areas in 1864. It is perhaps as well that this confusingly named body did not last very long. In 1868 Stanbury opted to join the Oakworth Local Board, which left Oxenhope (minus the Coldshaw area) to carry on under the Oxenhope Local Board.

UDCs: In January 1895 the Local Boards of Health became Urban District Councils. The following year Lees and Cross Roads were added to the Haworth UDC's area. In 1938, the UDCs were taken over by Keighley Corporation. Keighley, in its turn, was absorbed by the Bradford Metropolitan District Council in 1974.

The photographs in the two books are almost all of places within the township of Haworth. That is to say that they are of Haworth, Oxenhope and Stanbury and their surrounding farmland and moors. Where I have strayed outside the township boundaries, attention is drawn to that fact in the picture caption.

The sections into which the books are divided are inevitably rather arbitrary. Many of the photographs could have been placed in any one of two or more sections. Decisions had to be made, and I hope that the result will not look too illogical. What follows is an overview of the content of the five sections into which this first book is divided.

The first section sets the scene for the whole of the two volumes. These eighty-eight pictures include a number of general views of the district, usually taken from the surrounding moors. Most of the remainder are photographs of streets with a very few closer shots of features which would not easily have found a home elsewhere in these books. The pictures in this section, in conjunction with the maps at the beginning of the book, should enable the reader to build up a picture of the area.

The second section takes a look at houses in the three villages. The Worth Valley hasn't the rich heritage of seventeenth-century houses that is to be found in neighbouring upper Calderdale. There are, however, a few good examples of seventeenth-century buildings to be seen. Most of these are included here, but a few more examples will be found amongst the farms in the second book. Eighteenth-century houses, at least unaltered ones, are not much more common, but one or two will be found in this section.

The vast majority of the houses in the township are of the nineteenth century, or were rebuilt in that century. These vary from mill workers' cottages to mill owners' villas and mansions. Cottages for mill workers were built in small numbers in the first half of the century and in much larger numbers in the 1880s and 1890s. Both periods are represented. There is also a good selection of the grander houses that the mill owners built for themselves.

Schools of various kinds have educated the children of Haworth and district since at least 1638, when Christopher Scott endowed the Haworth Free Grammar School at Marsh. The various religious denominations competed in providing day schools during the earlier part of the nineteenth century. After the Education Act of 1870 the board schools soon took over from these earlier establishments. Coverage of school buildings is patchy, but we are fortunate in having Jonas Bradley's photographs of the Stanbury Board School, of which he was headmaster.

Places of worship abound in this area. Haworth parish church is an ancient foundation whose origins are by no means certain. Only the tower survives from an early period, made up of at least three sections of widely differing ages. Most of the building we see today was erected in 1880. It is, at least in part, owing to William Grimshaw's ministry in Haworth that Nonconformist chapels are so numerous. The Baptists and the Methodists of various factions have proliferated in the township since at least the late eighteenth century. The Salvation Army and the Roman Catholic Church came later. The photographs included here cover almost every place of worship that has existed in the township since the mid-nineteenth century.

The final section is the widest ranging, not to say most amorphous. Under the heading 'Leisure', I have found a home for everything from children's toys to the Home Guard. In between are Freemasons and Oddfellows, workers' outings, walkers both sedate and energetic, gardeners, musicians, an ill-fated balloonist and many others. The inclusion of the Haworth Rifle Volunteers and the Home Guard in this section may seem incongruous, but they certainly had a social element – and there was nowhere else for them to go!

Steven Wood
Haworth
2011

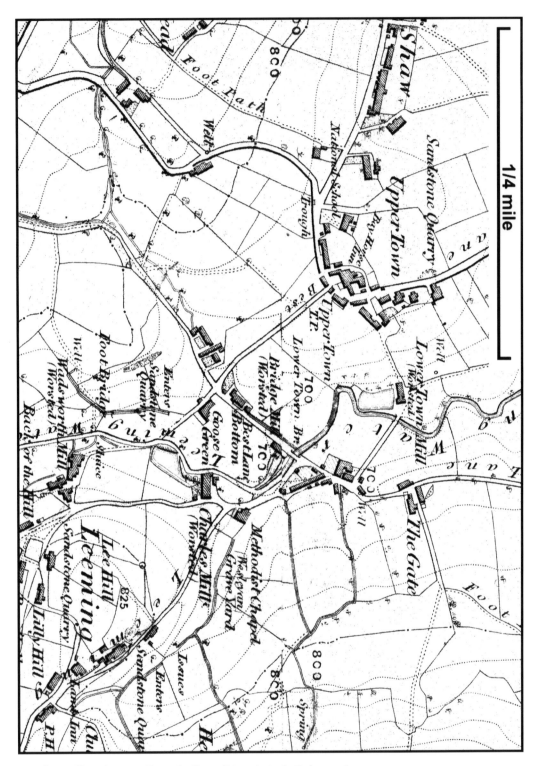

Oxenhope village in 1847. From the first edition six-inch Ordnance Survey map.

I

General and Street Views

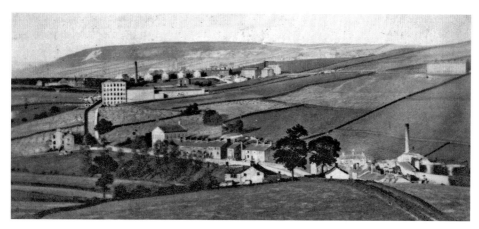

Lees Sike and Mill Hey, 1880s
One of a series of early photographs of Haworth Brow, this shows (*left to right*) Lees Sike Mill, Ebor House, the Primitive Methodist Chapel on Mill Hey, its earlier meeting place right of the two trees at Mill Hill, and the gasworks.

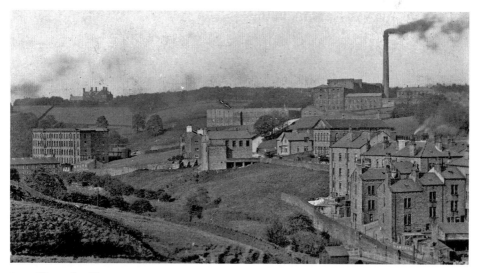

Lees Sike and Mill Hey, *c.* 1910
Lees Sike Mill has been extended across the road; the Masonic Lodge and police station were built in 1907. River Street (1892–94) is prominent in this view. Note the gas holder at Ebor Mill. The house on the skyline is Longlands.

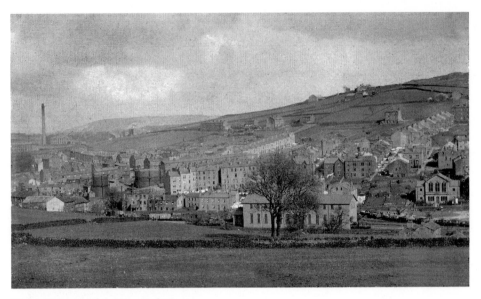

Haworth Brow, Early Twentieth Century
In front of the remodelled gasworks is the Fallwood Brewery. The large building in the centre is the railway goods shed. On the right-hand side is the 1892 Sunday school of the Bridgehouse Methodist chapel.

Haworth Brow, *c.* 1905
Haworth Brow was built in the 1890s to house workers from the newly expanded mills. The new retort house at the gasworks is approaching completion. The Butt Lane schools are prominent on the left. Bridgehouse Methodist chapel is on the right, with the Clarendon brewery above.

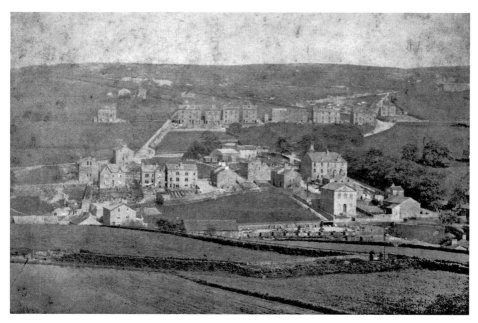

Haworth Brow, 1880s

An earlier view of the southern end of the Brow. Houses have been built on Prince Street and Hebden Road, but there are few others. The Bridgehouse chapel of 1884 has not yet acquired its Sunday school. Immediately above the chapel is the Clarendon brewery.

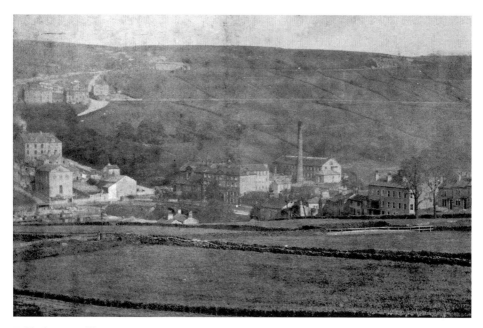

Bridgehouse Mill, 1880s

The farm, stables, house and mill at Bridgehouse were built by the Greenwoods. They failed in 1847, and the mill was bought by Butterfield who erected the mill buildings seen here. The old Blue Bell turnpike road drops from the moor to pass in front of the mill.

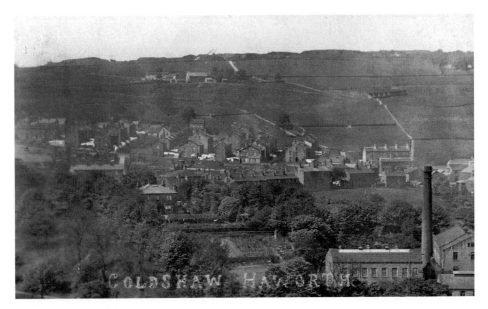

Coldshaw and Hole from Brow, *c.* **1915**
Front right is Bland's 1860s Ivy Bank Mill, as it was rebuilt in 1888. Bland's house with its gardens can be seen to the left of the mill. Beyond is the late nineteenth-century housing at Coldshaw. In the fields above are the Hough dam and Hole Farm.

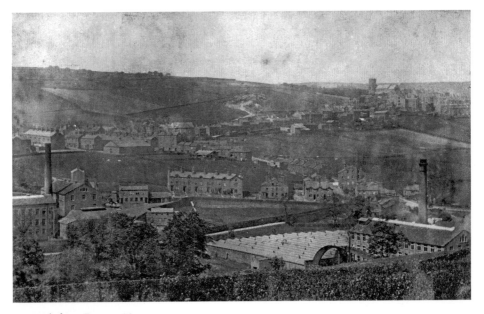

Haworth from Brow, 1880s
Bridgehouse and Ivy Bank mills dominate this early view of the village. Behind them are Ivy Bank Lane and Bridgehouse Lane. Further back are Sun Street with the 1873 Drill Hall and Haworth Main Street, leading up to the church.

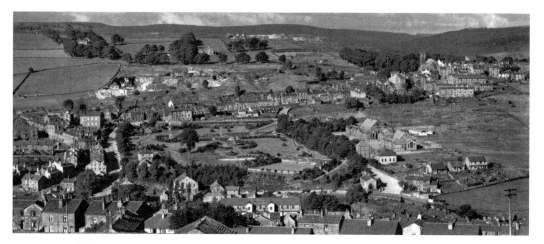

Haworth from Brow, Mid-Twentieth Century
This more modern view extends from Bridgehouse Lane on the left to Piccadilly and the top of Main Street on the right. Haworth Central Park and the Butt Lane schools occupy the middle of the photograph. This gives a good idea of the village as it was before the major changes of the later twentieth century.

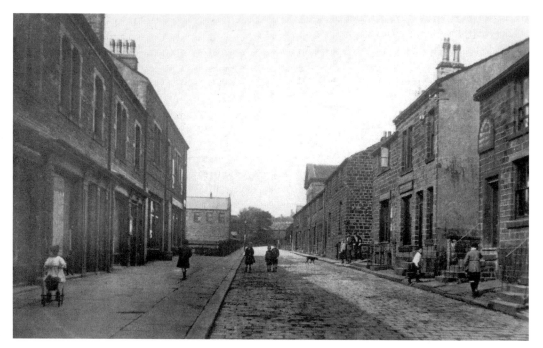

Mill Hey, *c.* 1930
George Atherton's barber's pole, which is just visible on the right, dates this photograph to about 1930. The first shop on the right was Nathan Wright's wheelwright's shop at the turn of the century. The setts had been laid by the council in 1879, when Mill Hey was declared a main road.

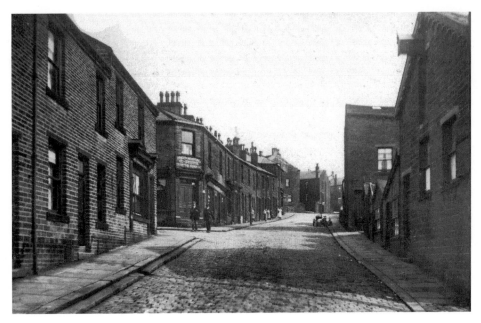

Victoria Road, *c.* 1940
In 1880, Haworth Co-operative Society resolved to build a branch to serve the rapidly growing Brow Estate. The 'commodious Shop and Dwelling-house' that resulted is seen on the left of Victoria Road in this photograph.

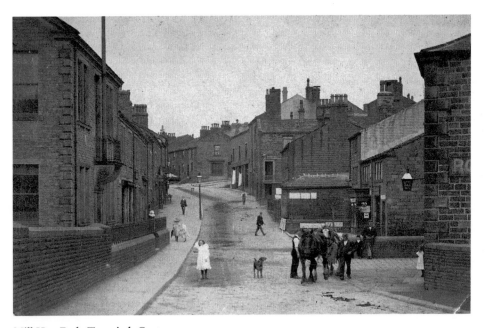

Mill Hey, Early Twentieth Century
The premises of the Haworth Conservative Club dominate the left-hand side of the street. Opposite the club are two shops, the second with the projecting frontage was William Pedley's grocery shop. Pedley also ran the Haworth Brow post office in the same premises.

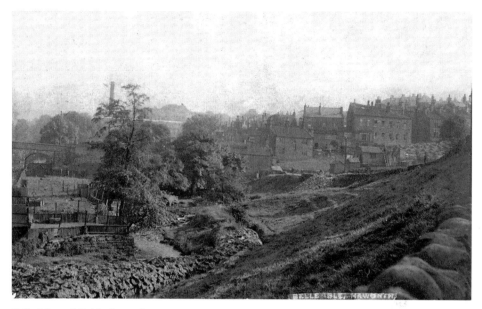

Belle Isle and Bridgehouse Lane, c. 1900
The Bridgehouse Beck runs down the middle of this view, and Bridgehouse Lane across the background. The 1907 Haworth Urban District Council buildings on Belle Isle Road have not yet been built. Note that Belle Isle Field, which was to become part of the park, is still a hay meadow.

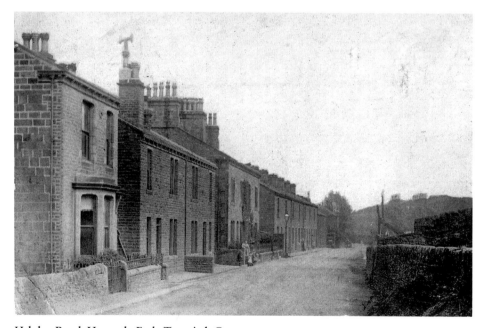

Hebden Road, Haworth, Early Twentieth Century
Hebden Road is part of a turnpike road, which was built around 1814, from Lees to Oxenhope and Hebden Bridge. The development of Haworth Brow extended along Hebden Road towards Lees. Sunny Bank, the second house along, was built in 1879.

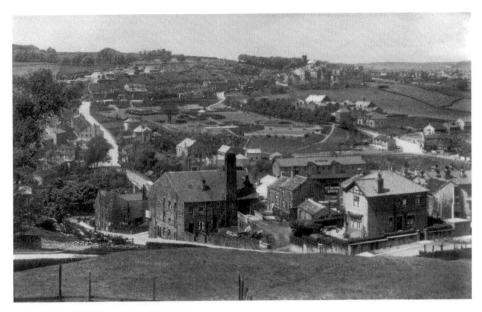

Brow Road, Mid-Twentieth Century
Victoria Road appears on the right as it approaches its junction with Brow Road. This junction was formerly the site of a farm. The building with the chimney is Elizabeth Parker's Clarendon Brewery, which closed in 1956. In the distance, the park is flanked by Bridgehouse Lane, Butt Lane and Main Street.

Belle Isle Road and Butt Lane from Bridge, 1924
In the foreground are the wooden Shepherds' Lodge building and the Haworth Urban District Council's workshops. Beyond the fields, which later formed the park, are the Butt Lane schools, the school caretaker's house and the new Haworth Institute, which is just approaching completion. The farm on the right is Lower Mill Hill.

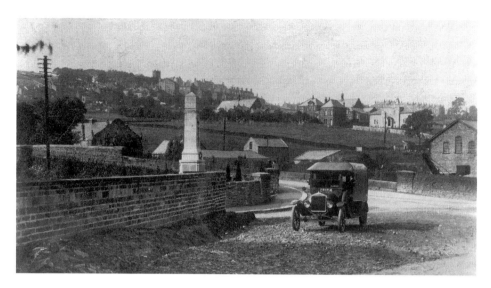

War Memorial and Haworth Village, *c.* 1925
A Ford Model T van stands near the War Memorial, which was unveiled in 1923. The ceremony was performed by Lt-Col. Bateman of the Duke of Wellington's Regiment. The memorial, which commemorates eighty-five Haworth men who died in the First World War, was dedicated by the former rector of Haworth, T. W. Story.

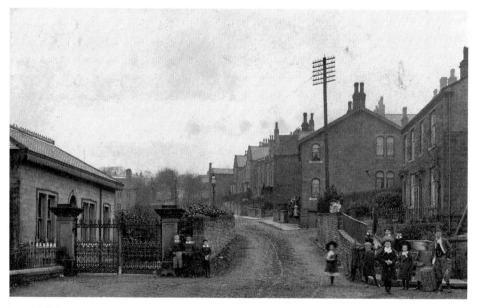

Ivy Bank Lane, *c.* 1900
The gates on the left guard the drive leading to Woodlands, which was built by James Greenwood, of Bridgehouse Mills, in 1832. The drive is flanked on the left by the Woodlands gatehouse. Strawberry House, in the foreground, is dated 1853. Ivy Bank Terrace (*middle right*) was built in two stages in 1870 and 1890.

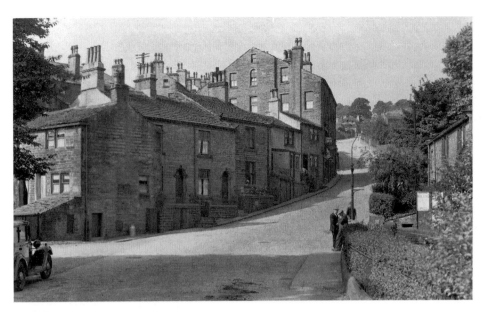

Bridgehouse Lane, *c.* 1940
Bridgehouse Lane still has its setts, which were replaced with tarmac around 1980. On the right was the Belle Isle Inn, one of Haworth's beer shops. The tall building on the left housed the draper's and fruit shops of Hiram and Amos Smith from the 1890s to the 1920s. The grocer's shop, seen here at No. 11, belonged to Clifford Sunderland.

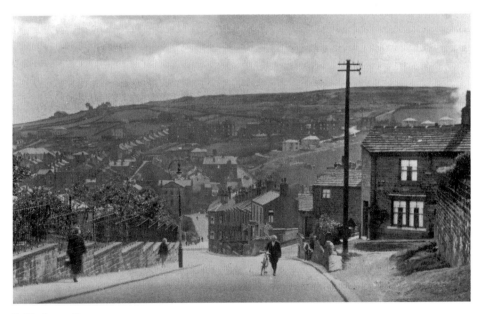

Bridgehouse Lane, 1930s
Looking down Bridgehouse Lane in the years before the Second World War (note the park railings are still in place). Few photographs survive of the now-demolished 28 Queen Street, which is on the right just past the wall of the Baptist chapel yard. New houses are being erected on Brow Road in the distance.

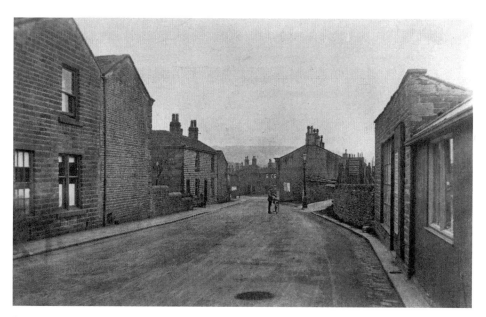

Sun Street, 1930s

Previously known as Stubbing Lane, Sun Street runs southwards toward Marsh and Oxenhope. On the right are a little Co-op fruit and vegetable shop, and the old premises of the British Legion. The houses opposite date back to the mid-nineteenth century. The second one is probably that which was kept as a dame school in the 1880s by Margaret Adcock.

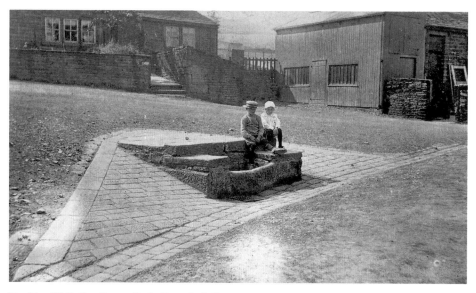

Ducking Well, Sun Street, Early Twentieth Century

Further down Sun Street was the Ducking Stool or Ducking Well. The well, seen here, was removed in 1932. It was intended to be erected in Haworth Park, but has since disappeared. The single-storey extension of the house behind the well is thought to have been used for wool combing. The shed to the right was Robert Ratcliffe's joiner's shop.

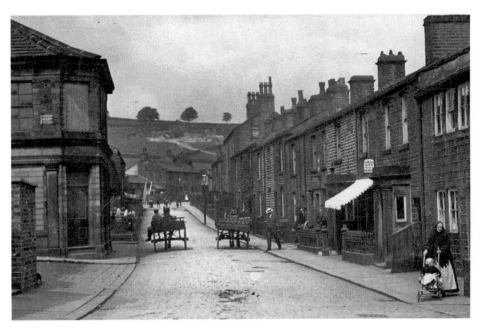

Sun Street, Ivy Bank Lane Top, Early Twentieth Century
John Whitaker's butcher's cart makes its way along Sun Street, presumably returning to his shop
at 102 Main Street. The other cart, from Sharp's Mineral Waters of Keighley, is no doubt making
a delivery to Clay's grocery shop outside which it stands. The shop with the awning was Rose
Binns's drapery.

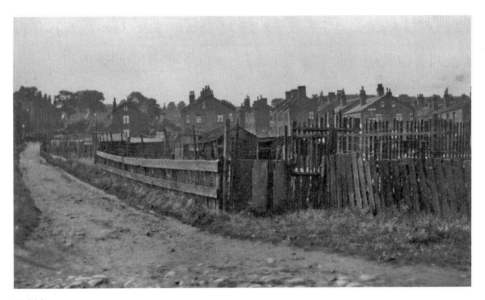

Coldshaw, 1933
The unmade track leading up to Cold Street is now Rosslyn Grove. Coldshaw is another area of
late-nineteenth-century workers' houses, which were developed in response to rising populations.
Between the lane and Cold Street are some of Haworth's once numerous allotments.

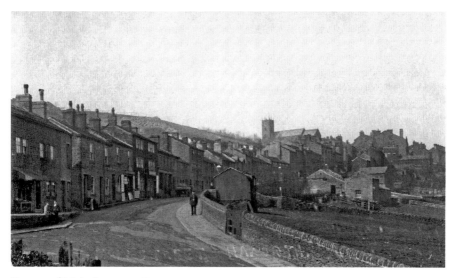

Bottom of Main Street, *c.* 1895
Our earliest photograph of the bottom of Main Street was taken before the new Co-op building was put up in 1897. The shops that can be seen here are Hall's bookshop, Kay's printer's and the old Co-op. Fields come right up to the Main Street, and quarry tips can be seen just above the street.

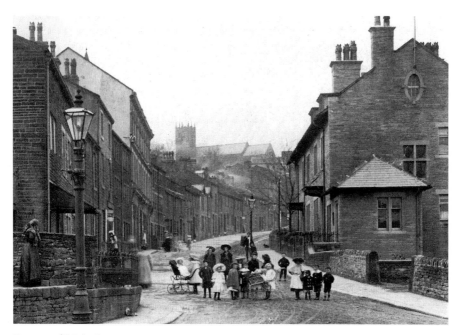

Bottom of Main Street, *c.* 1910
A decade or so later, Main Street has assumed a much less rural aspect. Where there were fields, there is now the house and office of William Henry Ogden, the registrar. A photographer at work is still enough of a novelty for children to gather and watch.

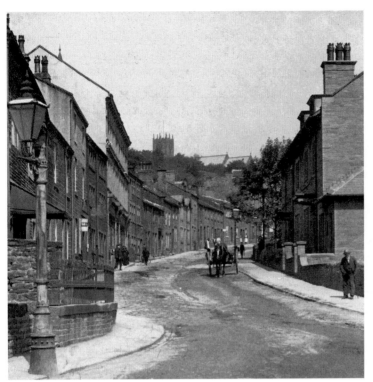

Bottom of Main Street,
c. 1910
Next door to A. E. Hall's
bookshop is a clogger or
bootmaker's shop. The
lamp standard at the
bottom of the street is
thicker than most. This
is because it was one of
those that also served as
a sewer vent. These did
not, as is often claimed,
use sewer gas for
lighting. Indeed the lamp
served largely to distract
attention from the vent's
main purpose.

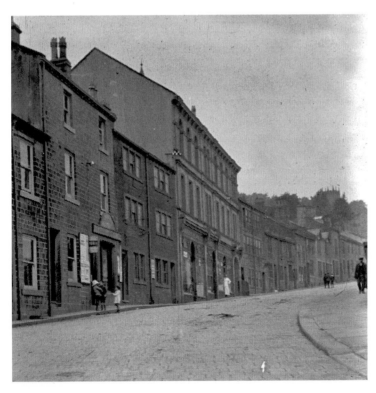

Bottom of Main Street,
1911
The Co-operative
Society's handsome new
store is well displayed in
this picture of the Main
Street in 1911. The third
storey of Alfred Edward
Hall's building still looks
quite new. Note that it
was not there in 1895.

Main Street,
c. 1900
The five and six
light windows of the
building next to the
Co-op
show it to be one of
the earliest surviving
buildings in Main
Street. It dates from
the early nineteenth
century and may well
have been used for
handloom weaving.
The taking-in door on
the top floor would
have been used for
moving yarn and
cloth in and out of the
workshop.

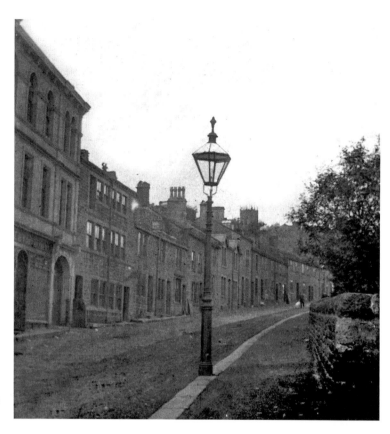

**Main Street, Early
Twentieth Century**
The widening of the
street, which was
carried out back in
1882, is still apparent
in this photograph.
The 1908 repaving is
also completed here.
The hanging sign on
the left advertises West
Parker's umbrella
shop. Parker also dealt
in yeast.

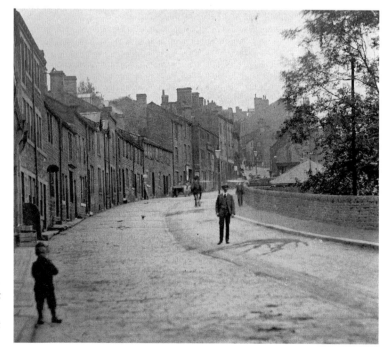

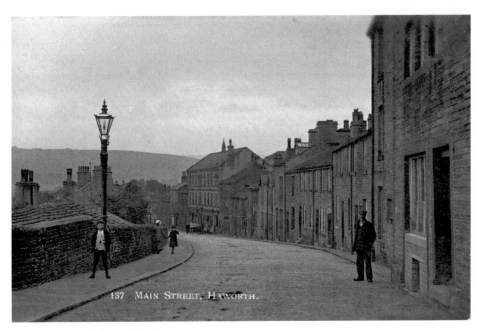

Main Street, Early Twentieth Century

Once past the Co-op, Main Street is largely residential up to the Fleece Inn, as can be seen in this view down the street. The few shops visible are West Parker's, Walt Rathmell's and Mary Jane Stansfield's. Rathmell was a saddler, and is remembered to have hung foxes' tails outside his shop. They can just be glimpsed here.

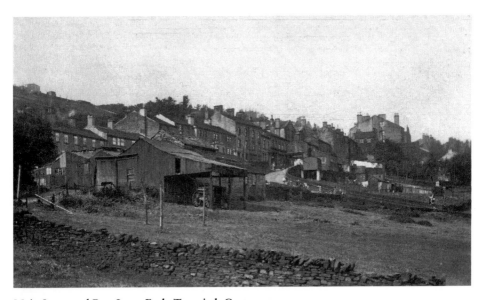

Main Street and Butt Lane, Early Twentieth Century

The junction of Butt Lane and Main Street, as it was remodelled in 1911. The handrail on Butt Lane was added in 1913. Toothill's barber's shop is seen on pillars at the top of Butt Lane. The buildings in the foreground belong to Hiram Hey the 'pop' maker.

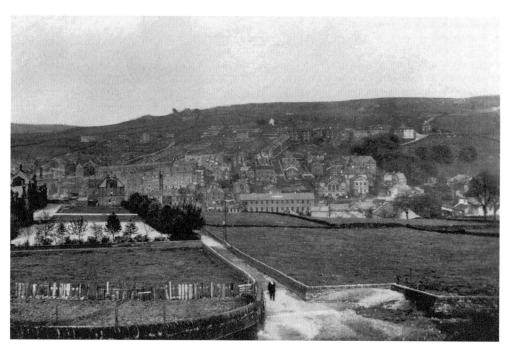

Butt Lane, *c.* 1921

The fields that were later to become Haworth Central Park – Bar Field, Ing, Belle Isle, Middle Field and Sunderland Field – lie to the right of Butt Lane. The Board schools are erected on the lower part of Butt Field. The upper part of that field is now the tennis courts. The photograph can be dated by the Brontë Cinema, which is being built on the Brow.

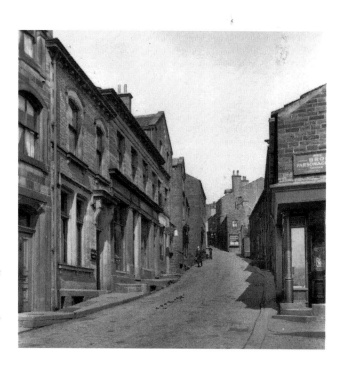

Main Street, 1930s
Main Street viewed from the top of Butt Lane. James Turner's decorator's shop, on the right, was formerly a cottage. The inserted doorway has made the unusual supporting pillar necessary. Notice the ornate panel in the shop door. On the other side of the street is Martin's Bank, at No. 74. Haworth had a number of banks at that time.

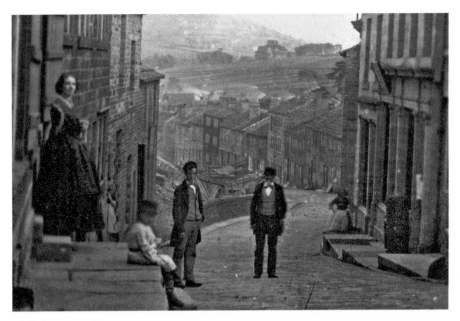

Main Street, *c.* 1880

This picture appears to show the lower part of Main Street before the 1882 street widening, and certainly before 1897 when the new Co-op was built. The four houses that occupied its place can clearly be seen. Behind the two men is the old wood yard.

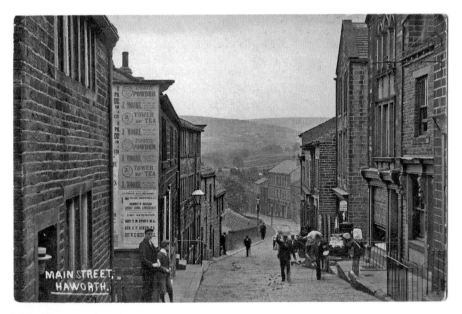

Main Street, 1906

The cottage on the left is one of two that were demolished around the 1920s. The posters for Tower Tea and Insect Powder are on the gable end of John Moore's chemist's shop. Across the street are Ogden's draper's, Stoney's butcher's and Whitham's boot shop. The poster advertising the Sunday school anniversary dates this photograph to 1906.

Main Street, *c.* 1910
Ogden's draper's, marked by the
rolls of linoleum, Whitham's boot
shop with its distinctive sign, and
Moore's chemist's shop are all
seen again on this photograph,
looking up the middle section
of Main Street. The shop at
No. 50 whose window faces
down the street was at various
times a hosier's, china dealer's,
hairdresser's and a herbalist's
shop.

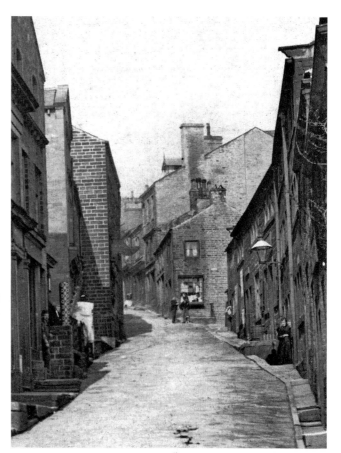

**Main Street, Early Twentieth
Century**
Zacharias Booth was in business
as a clog, boot and shoe dealer
at 87 and 89 Main Street for half
a century. He first appears in the
trade directories in 1889 and is
still there in the last directory to
be published in 1936.

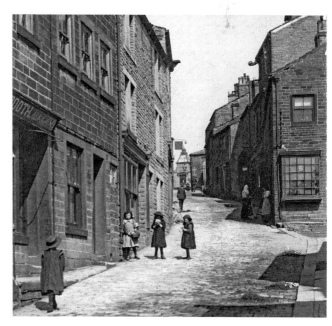

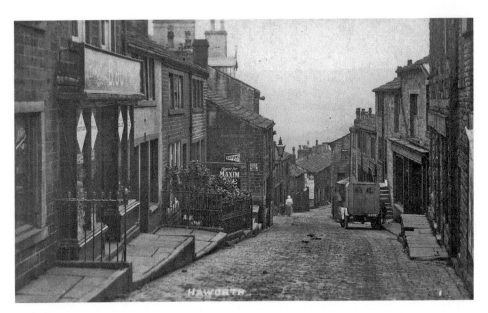

Main Street, *c.* 1920
Albert Scull had a number of different shops on Main Street in the 1890s, but had moved to the one with the van outside by 1901. He was to trade there until his son Norman took over, around 1930. Bert Joy traded as a grocer at No. 74 for a few years around 1920.

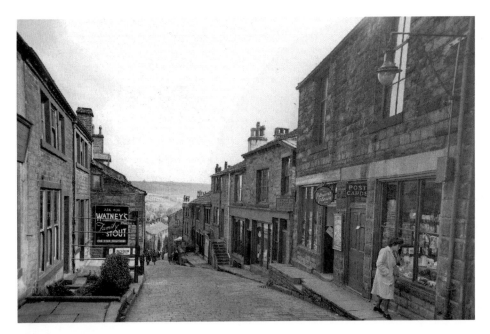

Main Street, *c.* 1940
Norman Scull has taken over his father's outfitter's shop at No. 111. The Watney's Stout and Robin Cigarettes advertisements draw our attention to Joseph Crabtree's ale merchant's shop, at No. 68, to the left of the sign. Crabtree's father, James, had run this business from 1889 or earlier. Frank Newsome had set up his news agency at No. 113 in the 1930s.

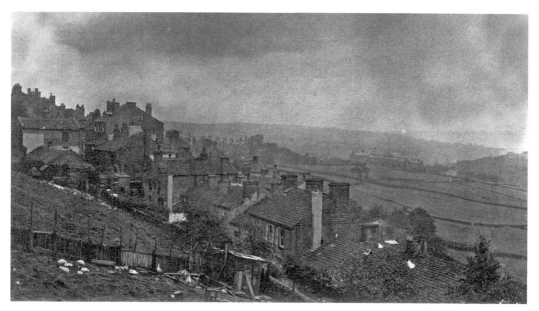

Haworth from South-East of the Church, 1910
This very unusual view of Main Street shows the backs of the shops and houses in the upper part of the street. Hens are being kept in the small plots of land behind the street – as they still are today in the allotments a little higher up the hillside. The photograph was taken by a Mr Welby, and comes from the collection of the Stanbury schoolmaster, Jonas Bradley.

Main Street, *c.* 1890
This very fine photograph of the upper part of Main Street is from a scrapbook kept between 1887 and 1893 by the Bradford historian William Scruton. The sign board on the cottage on the left of the street at No. 105 advertises Alfred Wood's cabinet-making business. The double-fronted shop at No. 111 would have been Manasseh Hollindrake's drapery at this time.

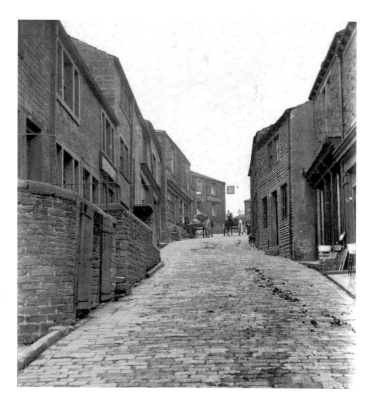

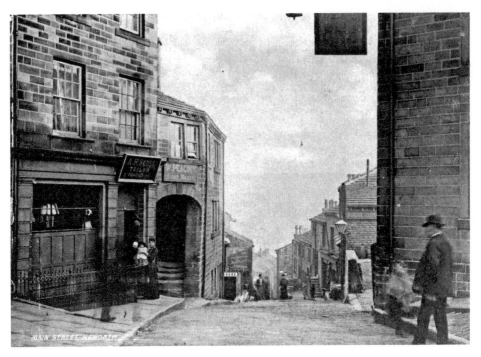

Main Street, *c.* 1895
In the left foreground is the first of the shops that Albert Scull kept before moving to No. 111 Main Street. Next door is the shop of the bootmaker Ward Peacock. Across the street is the Haworth Liberal Club. This was also one of the homes of the Haworth Mechanics' Institute – they were here from 1854 to 1877 and again from 1894 to 1925.

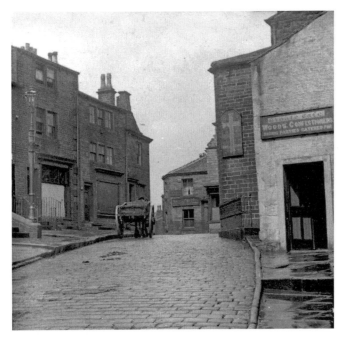

Main Street, *c.* 1900
In this photograph the shop to the right of the street light appears to be occupied by Agnes Burra, a confectioner. The shuttered shop next door at No. 125, once Feather's watchmaker's, is now Earnshaw's. Mary Wood had her Brontë Café here, at No. 94, in the 1890s. She later moved to No. 82.

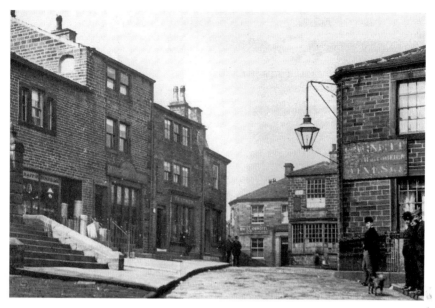

Main Street, 1893

The old Mechanics' Institute, with its fine bow window, is the most striking feature of this splendid old photograph. This was taken just a year or two before the Institute moved back down the street to the Liberal Club premises. Next to the church steps is Hartley's ironmonger's. Feather's watch and jewellery shop is also clearly seen. Both of these shops served as Haworth's post office at different times.

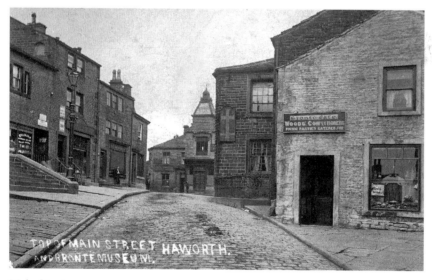

Main Street, c. 1900

The sign board of the Cross Inn is a prominent feature of this view. The old Mechanics' building was acquired by the Yorkshire Penny Bank in 1894, and they added the turret and the new doorway seen here. The first floor of this building was let out to the Brontë Society, and housed their first museum.

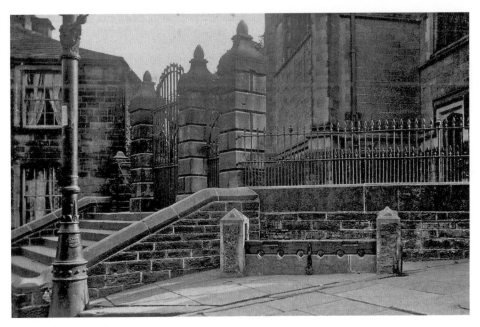

Old Stocks, Haworth, *c.* 1910
The stocks used to stand at the other side of the church gates, near the Black Bull. They were removed to the parsonage garden, before being returned to the position seen here. A stone set into the pavement records that this was done in 1909.

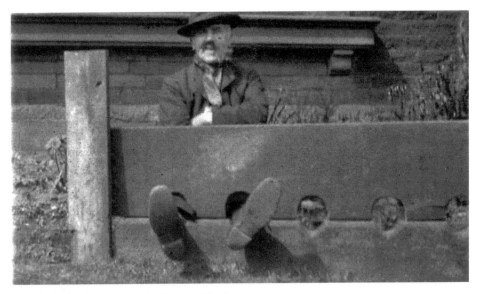

T. W. Story in the Stocks at the Rectory Garden, 1907
The stocks as they appeared during their stay in the parsonage (strictly speaking the Rectory by then) garden. The 'rogue' in the stocks is Haworth's Rector Thomas William Story. Comparison with earlier and later pictures shows how little of the original stocks survives today.

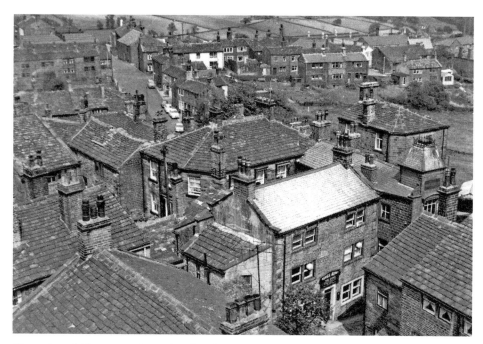

Haworth and Changegate from the Church Tower, 1966
The church tower commands clear views to the north and east. Here we see Church Street with the King's Arms. Behind and left of the pub is The Fold. The car-lined street is Changegate, seen shortly before many of its houses were demolished. In the right background is Townend Bottom, which was also to see some demolition.

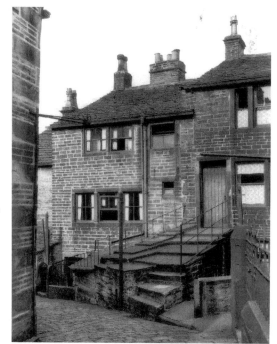

Church Street and Rear of Main Street, 1930s
The church railings, on the right, date this picture to some time before the war. The house of which only the corner is seen was later to fall into dilapidation and then be rebuilt. Note how the back door of 123 Main Street is approached via the roof slabs of its outhouses.

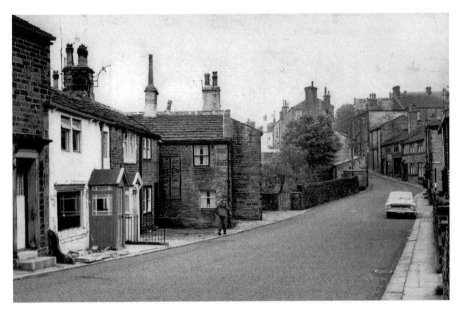

Changegate, 1963

Many streets in Haworth had their names changed in the 1870s and 1880s. Haworth Local Board decided that Ginnel should become Changegate in 1876. The name has yet to be satisfactorily explained. The change occurred too early for the Yorkshire Penny Bank at the top of the street to be responsible. The cottages on the left used to be called Spout Stones.

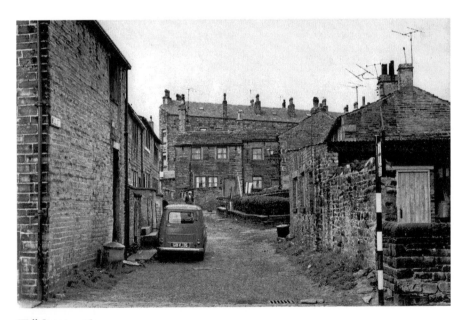

Well Street, 1963

Well Street took its name from the Head Well, which was the main water supply for the upper part of the village until reservoirs started to be built in the 1850s. The well seems to have consisted of three large stone troughs with water running through them. The quality of the water was not good – in summer it could be so foul that the cattle would not drink it.

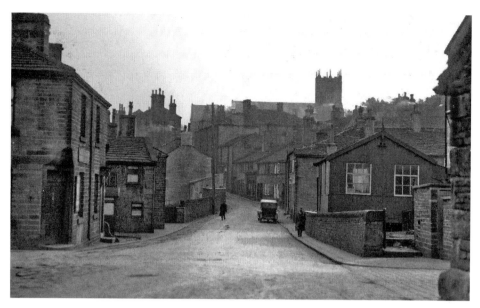

Changegate, Early Twentieth Century
Changegate seen from its junction with North Street. The corner shop on the left was knocked down when the road was widened. Beyond the shop one of the Spout Stones cottages can be seen. The wooden hut on the right belonged to John Wood the cabinet maker.

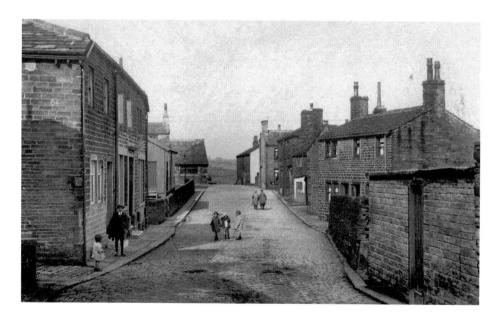

Changegate, Early Twentieth Century
A view of about the same date as the previous picture, but looking northwards down the street. John Wood's premises are seen on the left, and the Spout Stones cottages on the right. Behind the gas lamp is the barn of Townend Farm in North Street. The cobbled surface that Changegate still had is well displayed.

North Street, the Old Lock Up, 1959
The first mention of Haworth's old public prison was in 1839, when William Eccles was ordered to remove the coal-house he had erected against it. By 1889 it was in use as a fire station. In 1932 the council sold the building to F. A. Saywell, and it was used as a shop until its demolition around 1970.

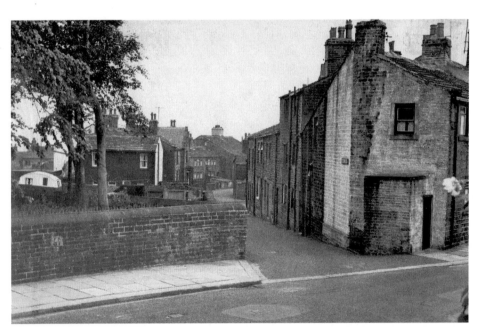

West Lane and North Street, 1963
The junction of North Street and West Lane, before North Street was widened around 1970. The road-widening involved removing the part of the West Lane Baptist burial ground seen on the left. It was originally intended to demolish the houses on the right, but the residents' objections prevailed.

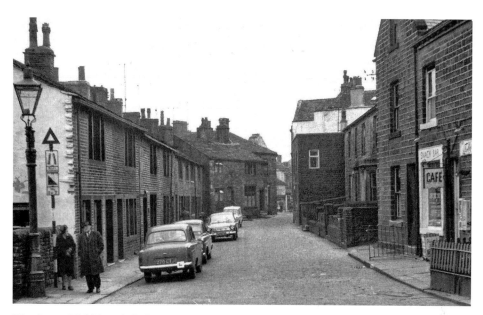

West Lane, Mid-Twentieth Century

Early-nineteenth-century cottages on the north side of the street face rather more imposing houses on the south. One of the latter houses is the Toby Jug café. The visiting motorist is warned of the steepness of Main Street, which he is about to drive down.

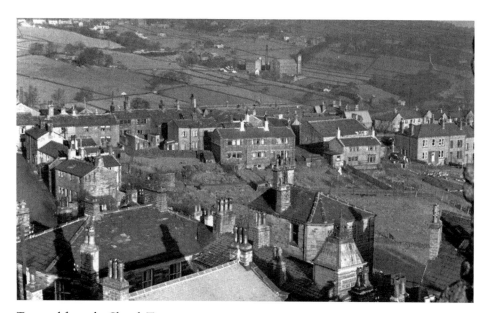

Townend from the Church Tower, *c.* 1945

The turret of the Yorkshire Penny Bank is in the foreground with Changegate to the left. The main focus of this photograph is Townend Bottom and the top of Mytholmes Lane. This area was to be radically altered when the road was widened.

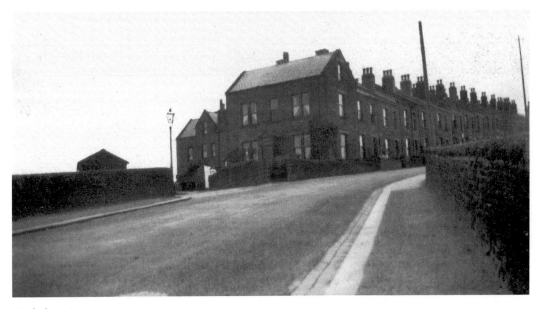

Mytholmes Lane, 1933
Haworth expanded in various directions as its population increased. Workers' houses were built on the Brow estate, behind Bridgehouse Lane and at Coldshaw. Some rather larger terraced houses were built on Mytholmes Lane, which drops into the Worth Valley from the top of the village.

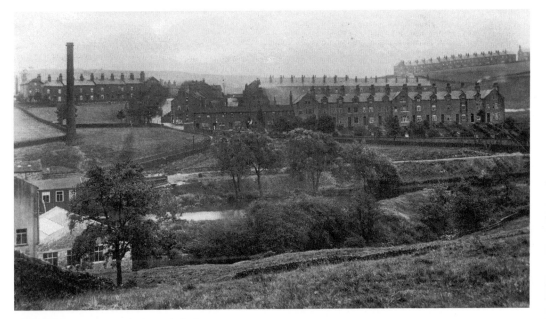

North View Terrace, Early Twentieth Century
The earliest houses here are the six cottages of Clay Brow, which date from the 1830s. North View Terrace provides another example of the larger terraces built in the Mytholmes area in the late nineteenth century. Much of this housing served Mytholmes Mill, seen on the left.

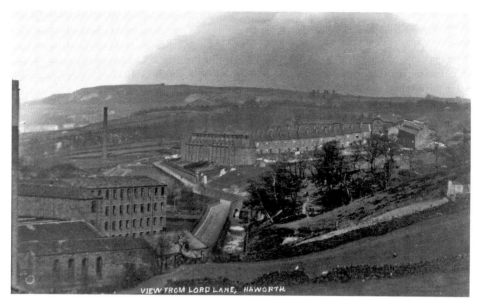

Springhead and Mytholmes from Lord Lane, Early Twentieth Century
As well as Mytholmes Mill, Hattersleys ran Providence Mill on the Oakworth side of the valley and Springhead Mill, which is on the left in this photograph. The road that runs below North View Terrace and crosses the Worth near Lord Wood was built to connect Mytholmes and Springhead mills.

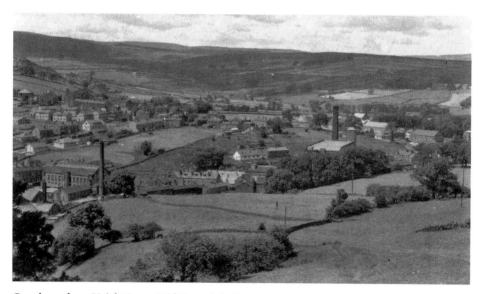

Oxenhope from Height Lane, Mid-Twentieth Century
The open character of Oxenhope village, which started as a cluster of smaller settlements, is apparent in this view from Height, on the moorland edge to the east. The Uppertown, Lowertown and Station Road areas are still quite separate.

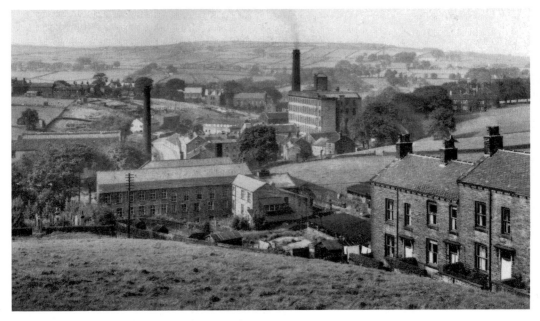

Oxenhope from Denholme Road, Mid-Twentieth Century
Here we see the Lowertown area of Oxenhope from the south. Perseverance Mill occupies the centre foreground, with Hield's five-storey spinning mill further back and right. Again, the open ground between Station Road and Uppertown is evident.

Cross Roads, Oxenhope, Muffin Corner, Mid-Twentieth Century
Here, at 'Muffin Corner' – to give it its local name – Station Road is crossed by the Lees and Hebden Bridge turnpike. Both are essentially new roads. Station Road dates from the advent of the railway in 1867, and the turnpike road from around 1814.

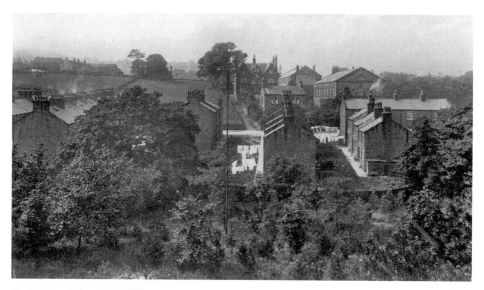

Station Road from East Ville, 1930s
The mill workers' houses on Elm, Ash and Oak Streets, in the foreground, contrast with the more spacious accommodation afforded by Fountain Villas – built in 1881 – in the centre distance. Lowertown Methodist chapel is to the right, with the Sunday school building behind it.

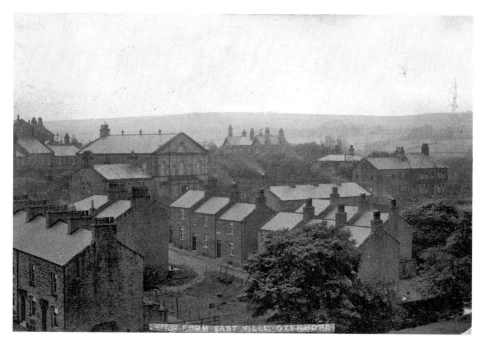

Station Road from East Ville, *c.* 1910
Ash Street takes up the centre of this view. The Methodist chapel is beyond it on the other side of Station Road. Two more substantial mill owners' houses are seen in the distance and on the right. The latter is Rose Bank with Greenwood's corn factor's premises attached.

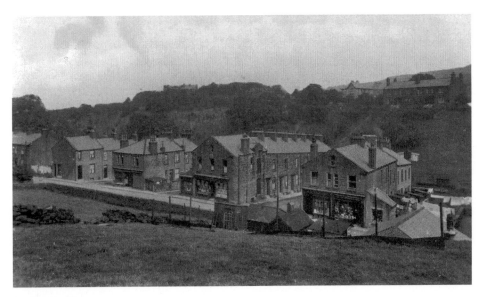

Station Road, 1930s

Station Road is seen here from the Cat Steps with Elm, Ash and Oak Streets running down towards the stream. Three shops can be seen on Station Road, and others were housed in the small buildings in the right foreground. The tiny shed, situated at the end of the field wall, has an incongruously grand window.

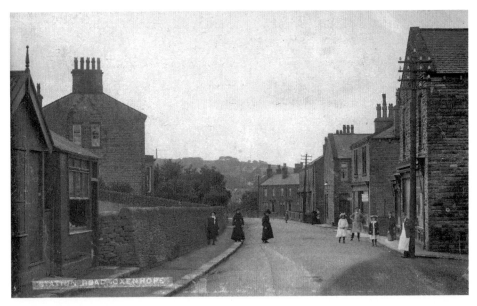

Station Road, Early Twentieth Century

Two of the stone-built shops and two of the wooden lock-ups, mentioned above, are visible in this view looking north along Station Road. The large house on the left is the Methodist chapel's manse.

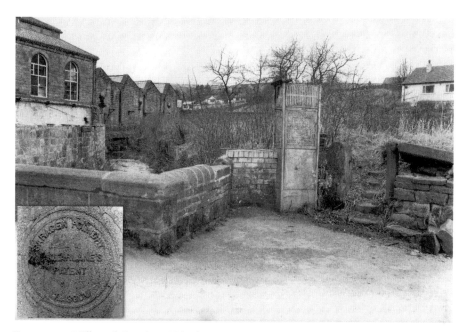

Lowertown Mills and Cast-iron Urinal, 1981
This cast-iron urinal, which stood near a bridge over Leeming Water, is representative of a type once quite common and now all but vanished. The inset shows an enlargement of the founder's mark, which is cast into the lower panel of the structure. Lowertown Mill's weaving sheds are on the left.

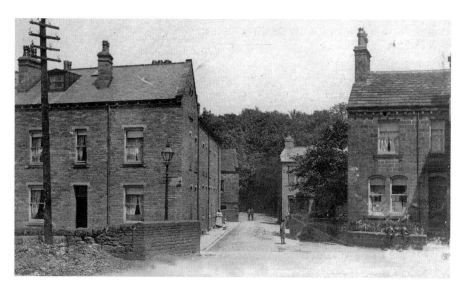

Lowertown, Yate Lane, Early Twentieth Century
Yate Lane leads away from the crossroads at Lowertown. The buildings on Station Road – houses to the left, and shop and house to the right – are late nineteenth century in date. Further up Yate Lane, a much older building is seen on the left. Opposite this is the end of Farra Street – once locally known as Shitten Lane.

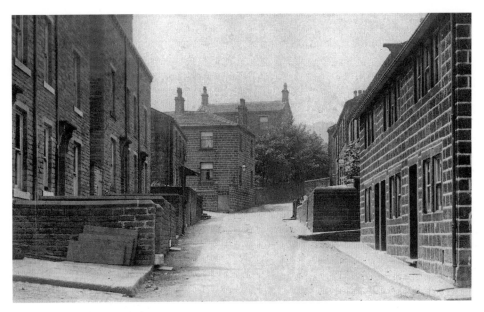

Lowertown, Early Twentieth Century
The upper part of Lowertown, with Goose Green off to the left, Hill House Lane continuing ahead and Best Lane out of sight, round the corner, to the right. The cottages on the right date from the earlier nineteenth century. The terraced houses on the left are perhaps about 1870, judging by the consoles over the doors.

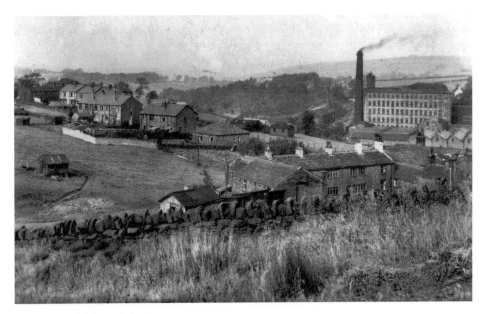

Best Lane, Mid-Twentieth Century
The early-nineteenth-century cottages with the six light windows in the foreground are at the bottom of Hill House Lane. Best Lane, with its modern houses, runs across the left half of the picture. Hield's Mill is seen in the right distance.

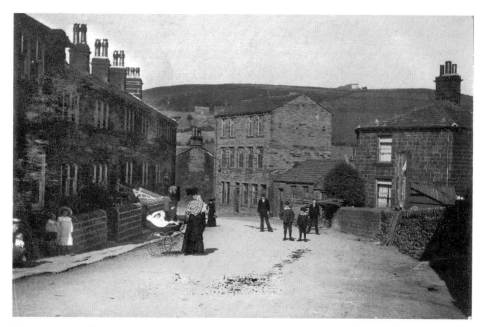

Uppertown, Early Twentieth Century

The top of Best Lane is just beyond the three-storey building on the right. This building probably dates from the late nineteenth century. The cottages opposite are well over half a century earlier, as is shown by their characteristic mullioned windows. The bystanders' clothing and the pram suggest an Edwardian date for the photograph.

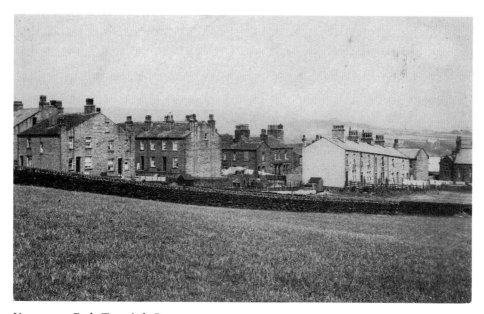

Uppertown, Early Twentieth Century

An unusual view of Grant Street, Pear Street, Apple Street and Church Street, across the crofts. The school building on the right shows that this picture was taken before the fire of 1925. Note the hen runs in the croft above Church Street.

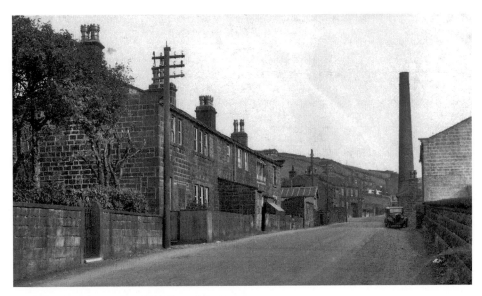

Denholme Road, Leeming, Mid-Twentieth Century
The tall chimney of Sykes Mill dominates this view of Denholme Road as it approaches the little village of Leeming. Leeming had one or two smaller mills, and the building opposite the chimney housed one of these. The little building by the motor car has been claimed as one of the smallest houses in the country.

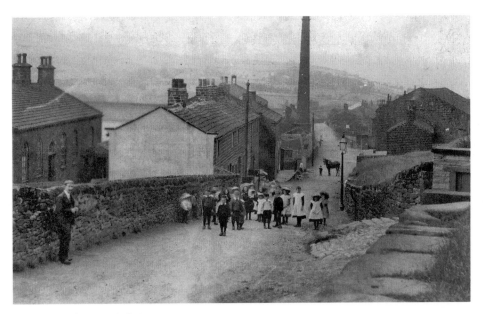

Leeming, Early Twentieth Century
Looking back down through Leeming, with the cottages once called Hills Stile on the left. The building set back on the far left was the Horkinstone Baptist chapel's Sunday school, which was bought by the Haworth School Board in 1910 for use as a primary school.

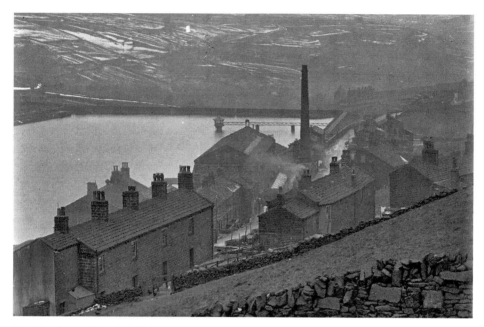

Leeming, Early Twentieth Century
This view of Leeming was taken from the steep hillside above the village. The centre is dominated by Sykes Mill, with Leeming Reservoir behind it. This was one of two reservoirs built to supply compensation water to the local mills when the Bradford Corporation impounded the water at the head of the Oxenhope valley in the 1870s.

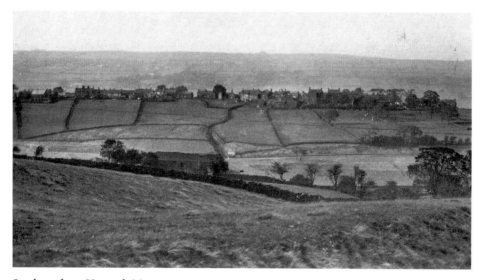

Stanbury from Haworth Moor, *c.* 1920
Stanbury sits on top of the ridge between the Sladen Valley and the River Worth. That ridge-top position is clearly seen in this view from Haworth Moor to the south. In the valley bottom Sladen Reservoir is being built. The line climbing gradually across the fields below the village is the railway, which brought clay to the reservoir from Stanbury Moor.

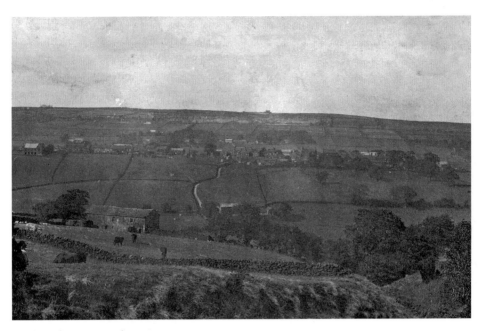

Stanbury from Haworth Moor, *c.* 1910
This view of Stanbury from Haworth Moor was taken before work started on the reservoir, and Smith Bank Farm still stands near the bottom of Waterhead Lane, which runs down the middle of the picture. The farm in the foreground is one of three on Enfieldside. There is now very little left of this building.

Stanbury from Cold Knowle, *c.* 1910
Stanbury's ridge-top site is again evident in this view from the west. The narrow fields that occupy the south-facing slope of the ridge are also clearly seen. These fields probably reflect the strips of a medieval open arable field. The lane in the foreground is Back Lane.

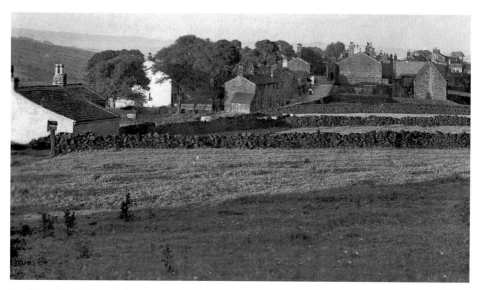

Stanbury, Early Twentieth Century
A closer view of the west end of Stanbury village. The building on the left was the site of a turnpike gate on the Blue Bell turnpike road, which ran through the village. On the right is an end-on view of Stanbury Board school.

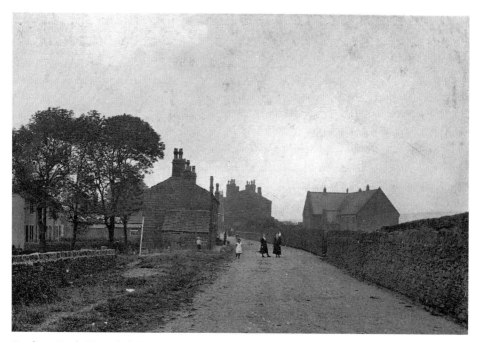

Stanbury, Early Twentieth Century
This early-twentieth-century view, of the road leaving Stanbury for Lancashire, gives some idea of the kind of road surface that prevailed before cars became common. The Board school is prominent on the right of the picture.

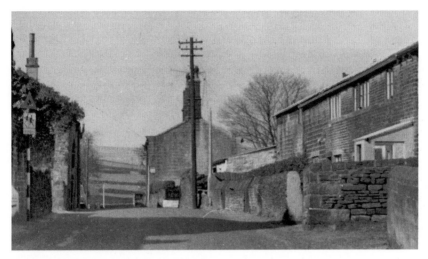

Main Road, Stanbury, Mid-Twentieth Century
The old turnpike road is here seen looking west as it leaves the village. The school is out of sight on the left, but its presence is clearly indicated by the road sign. The milestone beside the road sign is typical of the sort that marked turnpike roads of the West Riding in their later years.

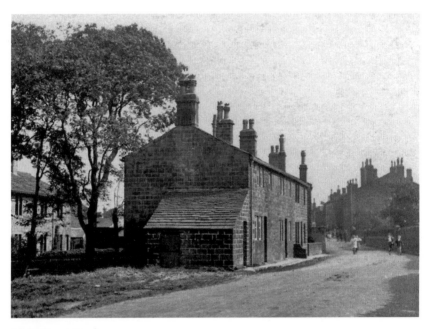

Main Street, Stanbury, 1930s
Another view of the Blue Bell turnpike road at the western end of Stanbury village. The school yard is on the right. Stanbury does not go in much for street names. The addresses are just a number and the name of the village. Those on the left here are Nos 104 to 108, Stanbury.

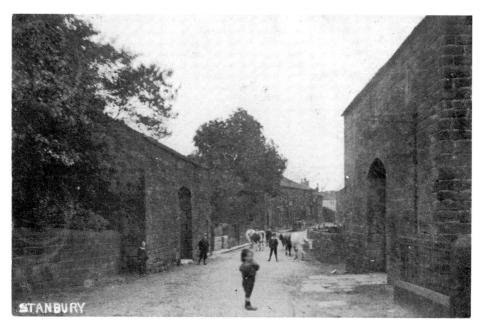

Main Street, Stanbury, *c.* 1905
Just how rural a village Stanbury was a century ago is shown by the two barns facing one another across the Main Street and the cows in the street itself. The building in the middle distance, with the cart outside, is the Friendly Inn.

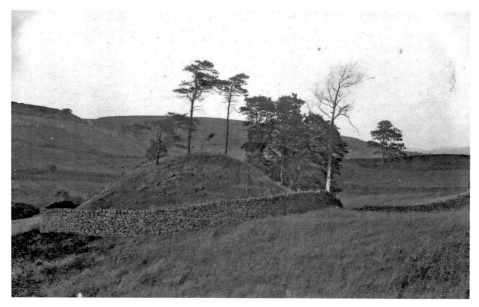

Silver Hill, the Mound, 1916
There has been much speculation about this odd mound at Silver Hill to the west of Stanbury. The name has lead to romantic tales of buried treasure. It is likely that the mound is largely a natural glacial phenomenon, but it may have been used as a lookout post in connection with the medieval Clitheroegate and one of its overnight stopping places on the hillside above Silver Hill.

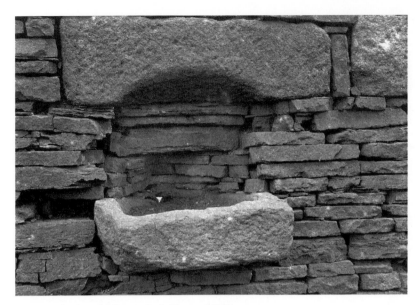

Stone Basin, in a Wall near Jack House, Withins, 1912
This feature of a field wall on Stanbury Moor has also occasioned much speculation. Suggestions have ranged from the sacred – a piscina – to the decidedly prosaic – a lant stone. There was definitely no church here, but there is some evidence that there might have been a house. Whatever it was it is no longer to be seen. The lower, basin-like part was removed many years ago, probably to grace somebody's garden.

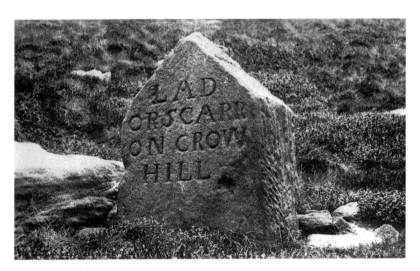

Lad of Crow Hill, 1930s
This striking boundary stone, the Lad of Crow Hill, marks the end of Stanbury and of Haworth township. It stands on the county boundary, and the heather beyond the Lad is Lancashire heather. This was long a disputed boundary, and many acres on the east side of the watershed have been in Lancashire since the early 1600s. This stone was placed here in the eighteenth century, as a result of renewed disagreement about the boundary.

Houses

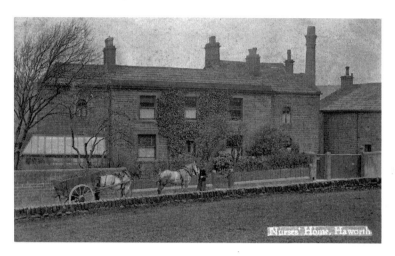

Ebor House – Nurses' Home, *c.* 1900
Ebor is an early-nineteenth-century mill owner's house, built in association with the nearby Ebor Mill. For much of the nineteenth century Ebor was occupied by members of the Merrall family who ran the mill. For a few years around the turn of the century, it was used as a nurses' home. At the time of the 1901 census, the occupants were two hospital nurses, a servant girl and three other women.

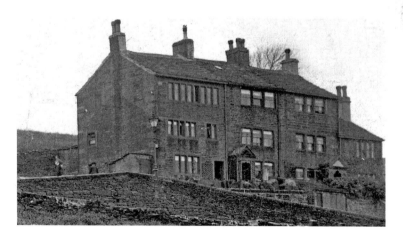

Lower Mill Hill Cottages, Early Twentieth Century
A fine row of cottages, dating from the late eighteenth or early nineteenth century. The one on the left has a very fine set of 'weavers' windows'. Although they may well have originally been weavers' cottages, by 1851 they were mainly occupied by wool combers. By this time much of the weaving was factory-based.

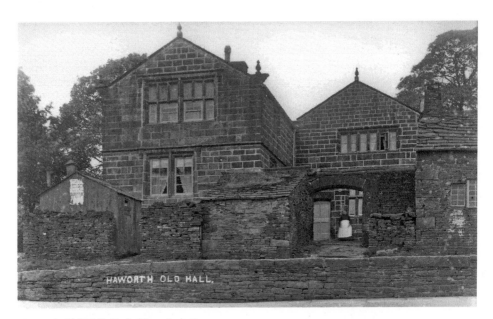

Haworth Old Hall, Early Twentieth Century
Haworth has relatively few seventeenth-century buildings; the Old Hall is one of the finest. It is said to have been built in 1627, and certainly looks to be of that period. Around the time that this photograph was taken it was occupied by members of the Dyson family who farmed and had a nearby stone quarry.

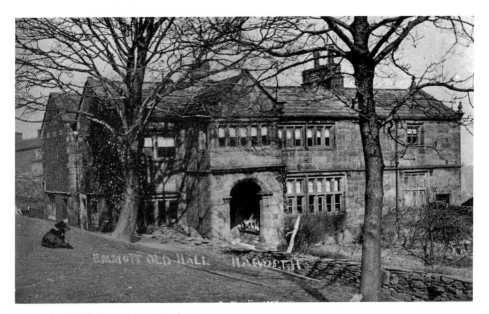

Haworth Old Hall, Early Twentieth Century
The caption on this picture makes explicit the traditional association of the hall with the Emmott family. The Emmotts were large landowners who lived just over the border near Laneshaw Bridge. They certainly owned the Old Hall, but did not live there. Nor did they build it – they did not acquire their Haworth property until over a hundred years after the hall was built.

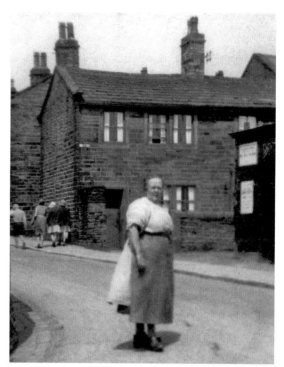

Sun Street, Emma Shackleton, *c.* 1930
A good example of an early-nineteenth-century cottage on King Street. The woman standing in her clogs and apron in Sun Street is Emma Shackleton. She was apparently as redoubtable a character as she looks. Amongst many other things, she was known for her skill at making blood pudding.

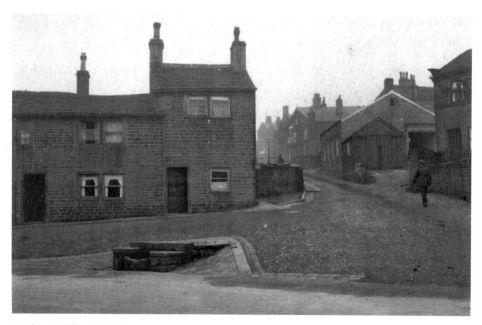

Ducking Well and Cold Street *c.* 1930
Early-nineteenth-century houses cluster round the Ducking Well, whilst later-nineteenth-century mill housing is seen further up Cold Street. The shed at the bottom of Cold Street was used as a tripe-boiling shed, but is better remembered as Dick Ratcliffe's garage.

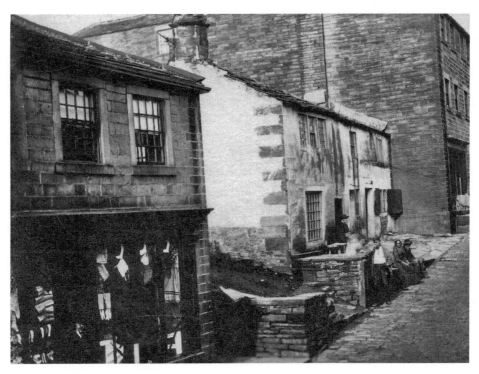

Main Street, Nos 81–87, 1870s
This is the only photograph that we have of unaltered eighteenth-century cottages in Main Street.
Buildings of this kind may well have been the common form of housing in the early years of Main
Street's development in the eighteenth century. Substantial quoins are evident despite the render.
The windows are small-paned and have thin, square-faced mullions on the first floor. Note also
the window shutters.

Main Street and Roper Street, 1963
This archway is a noted feature of the top end of Haworth Main Street. Oddly enough it has no generally accepted local name. It gave access to a group of terraced streets known at various times as Gauger's Croft, Brandy Row and Piccadilly. Lost in the shadow is the entrance to a house that extends over the top of the arch.

**Top Street and Main
Street, 1963**
Through the archway,
the first street
encountered was Top
Street, which is seen
here with the backs of
the Main Street houses
behind it. These houses
were probably built
around 1830 and were
demolished around
1969. The chimney
stack is worthy of
attention.

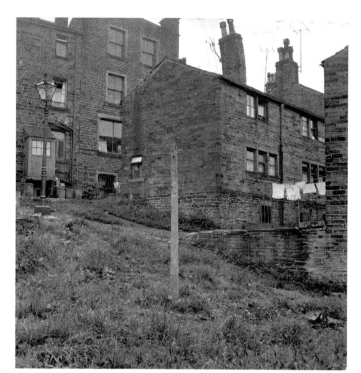

Mount Street, 1967
A little further down Piccadilly was Mount Street. The houses on the lower side of the street look
to be of a later period than those above. Map evidence suggests that these later houses were built
around 1850.

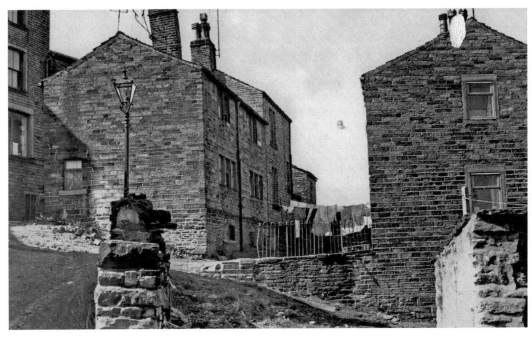

Top Street and Roper Street, 1963
Another view of Top Street with Roper Street below it. Those who were brought up here remember that it was inadvisable to linger beneath the railings at the end of Roper Street – the occupant of the end house used to empty her teapot slops over them.

Star Street and Croft Street, 1963
Two of the children of the 'Picc', as it was locally called, with Star Street behind them. The gas lamp is in Croft Street, which led from Main Street to the bottom end of Piccadilly. The rather imposing-looking car is a Daimler Consort of around 1953.

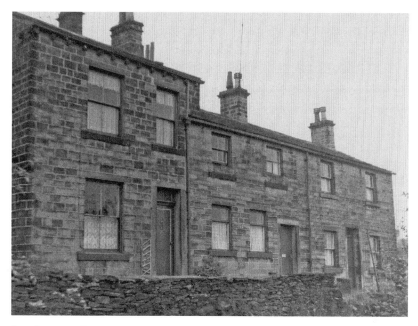

Star Street, 1967

Star Street was divided into two blocks and these three houses formed the more northerly of the two. On the plans of the Ordnance Survey and in the census returns, this is called Cork Street. People who lived down 'Picc' seem never to have used, or even known, this name. The same is true of the name Ivy Street.

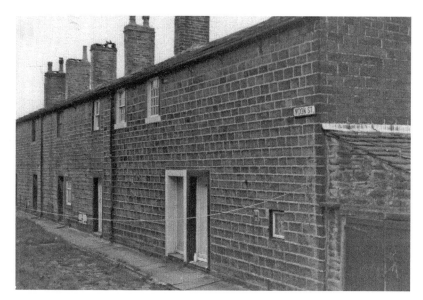

Moon Street, 1967

At the bottom of Piccadilly was Moon Street. Most of the streets in this part of Haworth seem to have been unsurfaced, but this looks to be cobbled, if much overgrown. The other side of Moon Street was labelled Ivy Street on the Ordnance Survey plans.

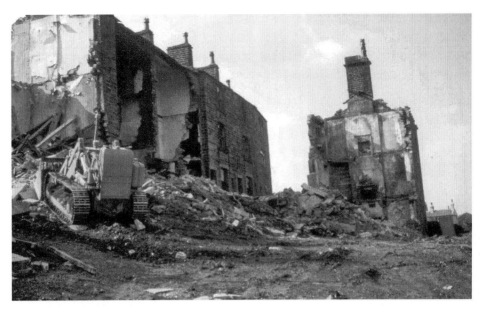

Piccadilly, Demolition _c._ 1969
During the late 1960s, Keighley Corporation bought up all the properties in Piccadilly. Despite a report by the Civic Trust, which recommended that most of the houses should be improved and preserved, the Corporation went ahead with the demolition of all the houses.

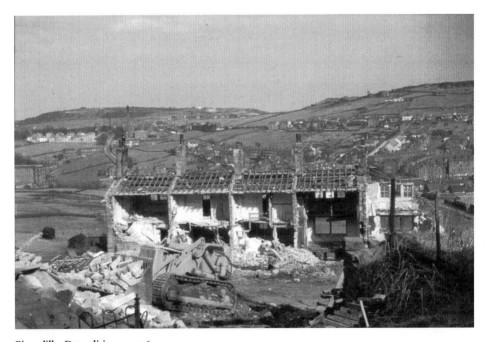

Piccadilly, Demolition _c._ 1969
After clearance the site of Piccadilly housed a garden centre and a car park. These, in turn, gave way to the new Health Centre. Both these views of the demolition of Piccadilly were taken by the late Jack Laycock.

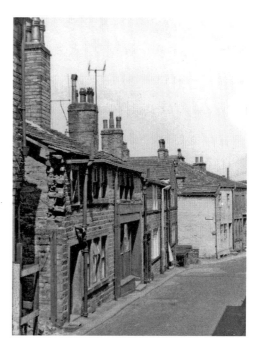

Changegate, 1967
Piccadilly was not the only area of Haworth to suffer from Keighley Council's ill-advised slum clearance schemes. A number of streets in the Changegate and North Street area were also demolished. Of the houses seen here, only the two by the lamp standard survive.

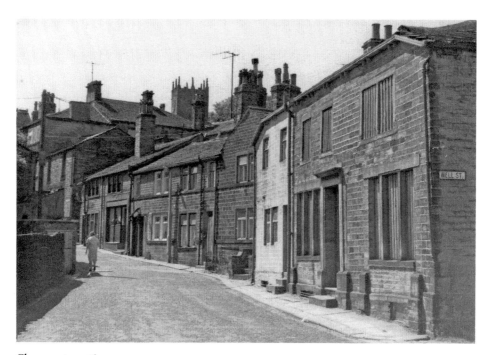

Changegate, 1967
The same stretch of Changegate is seen here from the other end. The large building at the top of the street is the White Lion Inn. A shop front is seen a little further down, but the shop looks to have closed. The house at the end of Well Street had been bought by Keighley Corporation in 1963 and is boarded up, although it was one of the very few that had not been condemned.

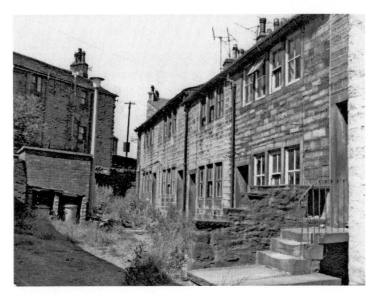

Hird Street, 1967

These cottages on Hird Street were declared unfit for occupation due to numerous shortcomings. They had no baths, few had inside lavatories, and most suffered from poor ventilation, rising damp and leaking roofs. Even the Civic Trust agreed that Hird Street and Well Street should be demolished. Had they survived a decade or two longer, a different view may well have been taken.

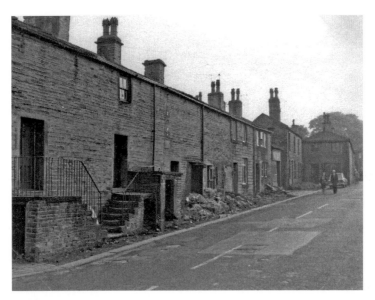

North Street, 1968

These houses on North Street were bought up for demolition between 1965 and 1967. Here, most of the outhouses have already been knocked down and the houses were very soon to follow. Note the old lock-up at the end of Gibb Lane.

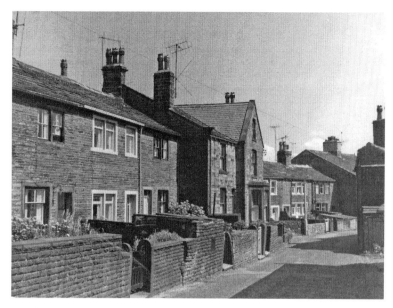

North Street, 1967

Most of the north side of North Street escaped unscathed. Flanked on either side by early-nineteenth-century cottages, the larger house looks to be a mid-nineteenth-century building, which has been much altered later in the century. North Street was another that had its name changed in 1876 – it used to be called Back Lane.

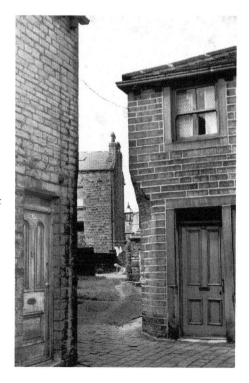

North Street and Acton Street, 1963

The entrance to Acton Street from North Street shows a very good example of a chamfered house corner. This allowed the largest possible house to be erected on a corner site without obstructing the passage of traffic into the side street. It was in Acton Street that Haworth's wise man Jack Kay lived.

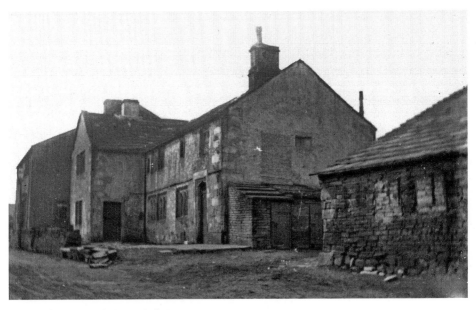

Townend Farm, Early Twentieth Century
As already mentioned, Haworth has few seventeenth-century buildings. Townend Farm is one of the best. It has an unusual type of T-shaped floor plan, which is mostly found in the Burnley area. When this photograph was taken, it was still a working farm and looks a little run down. It has since been restored to a very high standard.

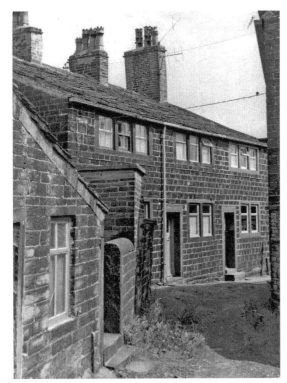

Little Street, 1967
Little Street is tucked away behind North Street, and escapes the notice of most visitors. These houses give us some idea of what might have been done with many of those that were destroyed in the name of slum clearance.

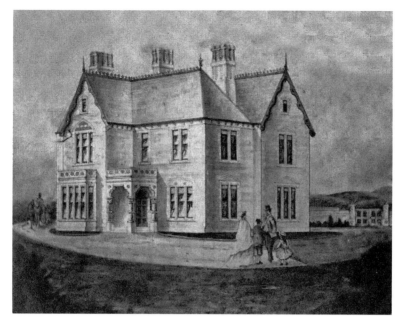

Ash Mount, *c.* 1869

Ash Mount was built for Dr Amos Ingham in 1870. It was described in the *Keighley News* as 'the beautiful mansion at the north end of Haworth'. Ash Mount made such an impression that the trade directories from 1871 to 1927 all had an extensive description of the house and grounds. It has the distinction of having had an entire book written about it (*Ashmount, Haworth* by S. R. Whitehead, 2010).

Branwell Drive, 1970s

Haworth and Oxenhope have both seen considerable development in recent years. New houses have been built on the old clearance sites and previously undeveloped sites. Branwell Drive is part of a development in the Mytholmes Lane area, which was built around 1970.

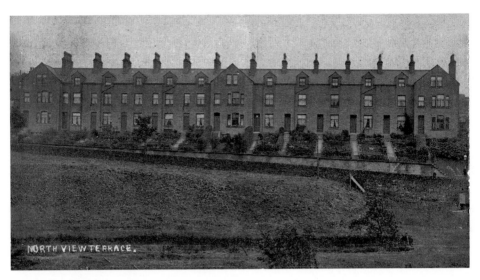

North View Terrace, *c.* 1900
North View Terrace was built by Hattersleys around 1890 for workers at their three mills – Mytholmes, Spring Head and Providence. In the 1901 census, most of the occupants were employed as combers, spinners and weavers. The two houses at the right-hand end of the row were opened in 1931 as a hostel for Irish girls who came to work in the mills.

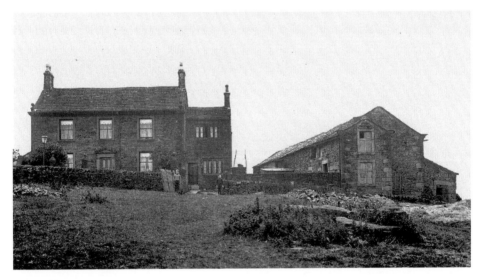

Manor House, *c.* 1900
Haworth Manor House is a handsome Georgian re-fronting of an older house. The cottage on the right-hand end of the house gives some idea of the probable style of the earlier building. The farm buildings to the right were seventeenth and eighteenth century in date. They have since been demolished.

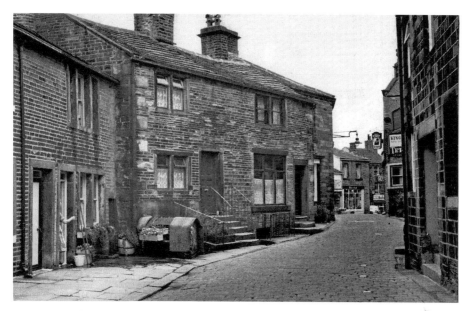

West Lane, White Lion, 1963

The two houses in the centre of the picture are now part of the Old White Lion Inn. One of them used to house the Haworth Conservative Club. The tiny door behind the tub of plants used to give access, via a narrow gap between the houses, to a privy. This privy emptied into a midden in the yard below. The Babbage report of 1850 tells us that these middens were rarely emptied.

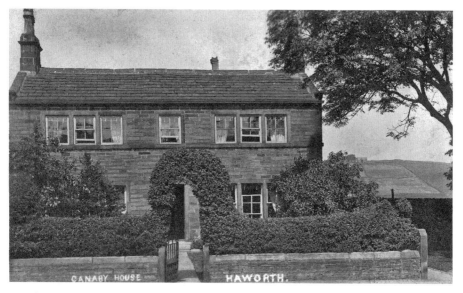

Canaby House, *c.* 1910

Canaby House is a handsome double-fronted building of the early nineteenth century. It used to be known as Near Sutcliffe, after its owner Joseph Sutcliffe. The occupant in 1851 was George Hughes, who was the minister at West Lane Wesleyan Chapel. The wall in shadow on the right is that of Haworth's public pinfold.

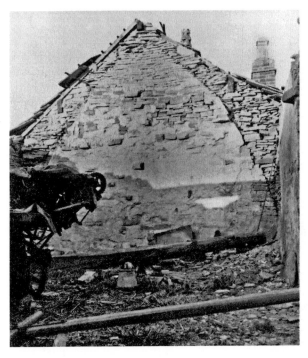

Crock House Ruins, 1948
The ruinous state of Crock House, on Black Moor Road, allows us to see the outline of one of the cruck timbers that were its principal supports. Cruck-built houses must have been common in the Worth Valley at one time, but survivals are rare. The old Crock House has now gone completely.

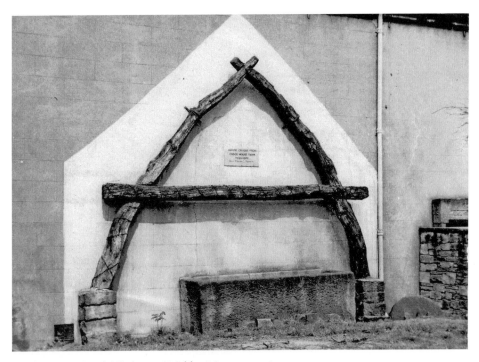

Crock House, Cruck Timber at Keighley Museum, 1960
The cruck timbers removed from Crock House went to Keighley Museum, where one was displayed outside the museum. When the museum moved from Eastwood House to Cliffe Castle the crucks went into storage and are no longer on display.

North Ives, Heraldic Plaster, Early Twentieth Century
North Ives is one of the older houses in the valley of the Bridgehouse Beck between Haworth and Oxenhope. It dates from the seventeenth century, and has many interesting features. Among them are a number of decorative plaster panels, including those seen here above the kitchen fireplace.

North Ives, Door, 1914
Another notable feature of North Ives is the old, oak-studded door in this photograph. It still survives, but is no longer *in situ*. The four-centred arch of the doorway is typical of the period.

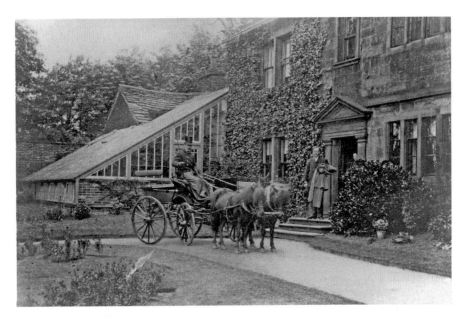

Old Oxenhope Hall, *c.* 1900
Dr Dobey of Keighley stands at the door of Old Oxenhope Hall, with the coachman ready to convey him back to town. The house is mainly associated with the Greenwood family who owned the adjoining textile mill. At the time this photograph was taken the house was occupied by members of the Holmes family who were farmers. The Greenwoods were at Ashmount House in Haworth.

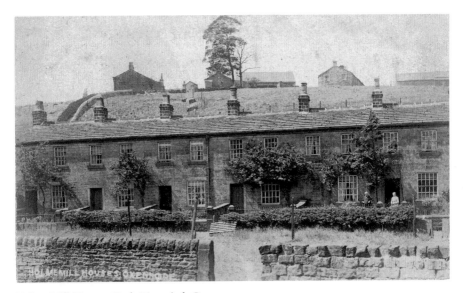

Holme Mill Houses, Early Twentieth Century
Feather Mill Row, to give it its local name, looks remarkably rural for a row of mill workers' cottages just off Station Road in Oxenhope. This is because of the scattered nature of the village, commented on earlier. The row was built in 1851 by John Feather and John Speak who owned a worsted spinning mill nearby. They themselves were amongst the first inhabitants.

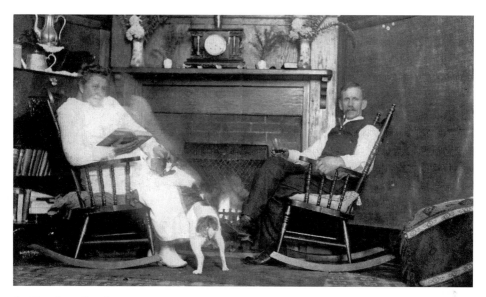

An Oxenhope Interior, 1919
Unfortunately this Oxenhope couple are unidentified. Photographs of ordinary domestic interiors are very scarce and we are fortunate to have this example. The ghost image of the woman is probably due to a combination of dog, rocking chair and the long exposure times of the day.

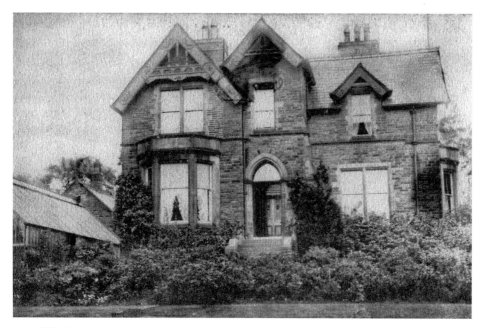

Fern Hill, Oxenhope, *c.* 1900
Fern Hill was built in 1873 by the Pawsons of nearby Wadsworth Mill. In 1881 it was occupied by Edwin Pawson, flyer and spindle maker, his wife Ruth Rebecca, their five daughters and the two sons who were to succeed to the business. Pawson's factory is a rare example in Haworth township of a textile engineering works. The Pawsons later concentrated on spring making.

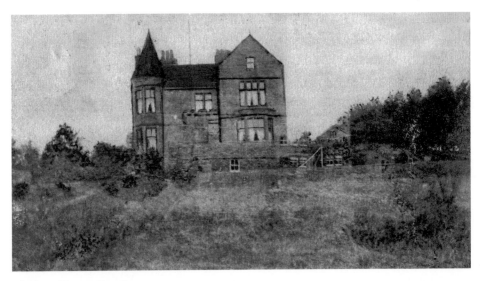

Gledhow Mount, Oxenhope, _c._ 1900

Some rather heavy-handed retouching is evident in this postcard of one of Oxenhope's vanished houses. Gledhow was built by John Henry Beaver around 1890. Beaver was a mohair spinner in business in Keighley. He served as a JP and as vice-chairman of the Oxenhope Urban District Council. During the 1939–45 war, Gledhow was run as a hostel for elderly evacuees by a group of conscientious objectors.

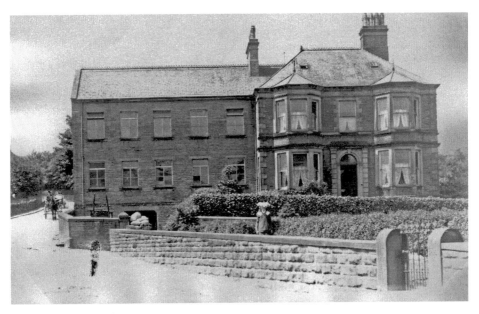

Muffin Corner, Oxenhope, _c._ 1910

Rose Bank was built in the early 1870s by Joseph Greenwood, a corn merchant and miller. The attached building on the left was used for the corn business. Joseph's son James William had the nickname 'Muffin' Greenwood, from a product he is supposed to have made. The name is still used for this part of Oxenhope by older residents.

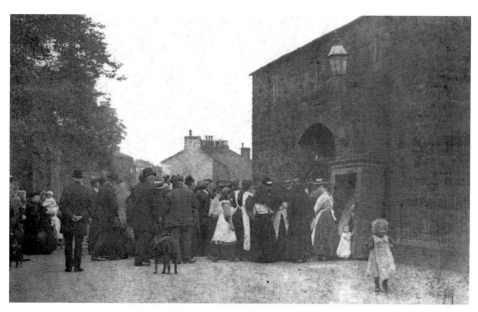

Stanbury – Old Tawse's Sale, 1910

Dozens of people crowd the main street of Stanbury village for a sale – presumably of household contents judging by the wardrobe propped up against the wall of the barn. One wonders whether 'Old Tawse' might have been one of the Toase family of Stanbury, or perhaps one of the retired schoolmasters?

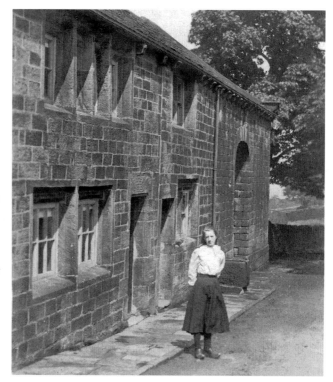

Pollard House, *c.* 1915
Immediately north of the main road through Stanbury is a quiet, unmade lane that stretches almost the entire length of the village. On a plan of 1894 it is called Back Lane, but this name is not used locally as there is another Back Lane at the west end of the village. Pollard House is a very attractive laithe house dated 1727. A note on the back suggests a First World War date for this picture.

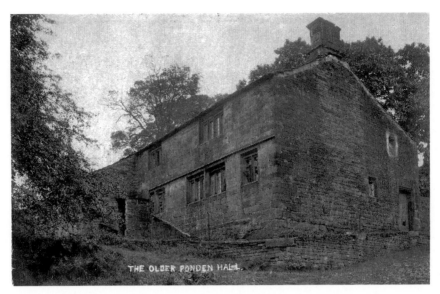

Scotchman's House, 'the Older Ponden Hall', Early Twentieth Century
Opposite Ponden Hall stands the new Ponden House. This is the building which previously occupied that site. There has been much debate about whether this is, in fact, older than the Hall or not. The name Scotchman's House may be a reference to one of those 'scotchmen' who were travelling salesmen rather than to a Scot. This house was also known as Bridget End.

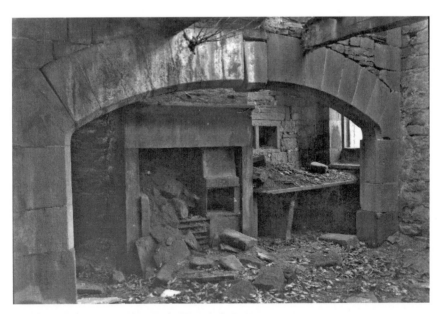

Scotchman's House, Interior, Early Twentieth Century
A small range has been inserted in an eighteenth- or nineteenth-century fireplace. To the right of the fireplace is a stone bench, with storage spaces behind. The huge arch that dwarfs the whole may be the remains of a much earlier fireplace.

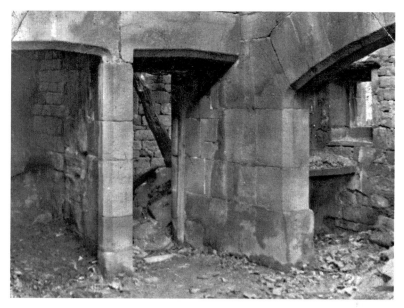

Scotchman's House, Interior, Early Twentieth Century
In this view of the same arch, we can see a small window that might perhaps have lit seating inside the old fireplace. The doorways to the left look to be of seventeenth-century date.

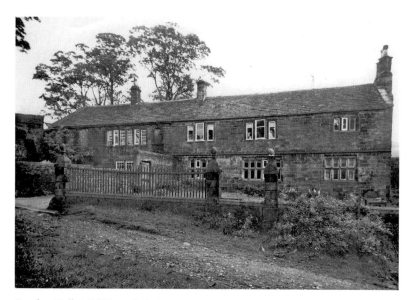

Ponden Hall, Mid-Twentieth Century
On the left is the extension to the Hall, built in 1801. The windows and end chimney stack of the older part of the building suggest an early seventeenth-century date. The two first-floor windows with three lights each are later insertions. Ponden Hall was, for centuries, the home of the Heaton family, who were clothiers, farmers and quarrymen.

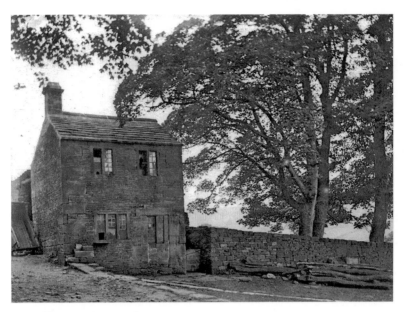

The Old Peat House, Ponden, 1916
This little building just above the Hall was apparently used as a peat store. Peat was an essential fuel for these moorland houses, where coal and timber were scarce locally and expensive to fetch in from outside the immediate area. Peat pits abounded on the high moors of Haworth township. One small peat pit on Oxenhope Moor is still occasionally worked today.

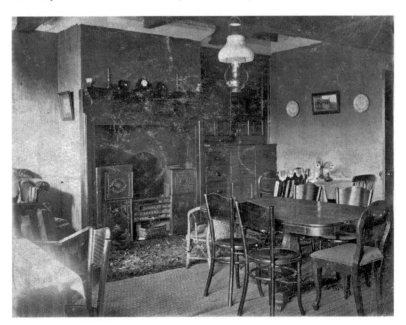

Ponden Hall, Interior, 1930s
The numerous tables and chairs show that the Asquiths, like many of the moorland farmers, provided teas for passing walkers and trippers. Note the well-leaded range, the tab rug and the oil lighting.

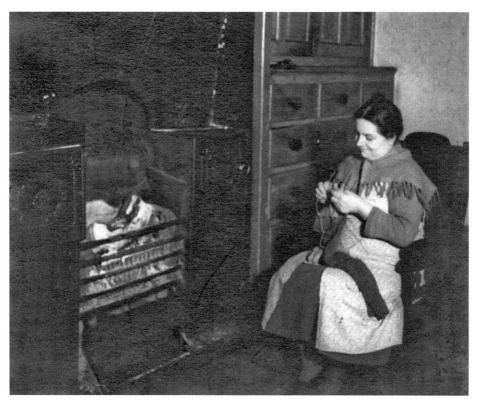

Ponden Hall, Interior, Mrs Asquith, 1930s
The Asquiths were at Ponden during the 1930s and 1940s. In the early 1950s they were succeeded by Sam Dyson, the last farmer to live at Ponden Hall. The room in which Mrs Asquith sits by the fire knitting is the same living room that features in the previous photograph.

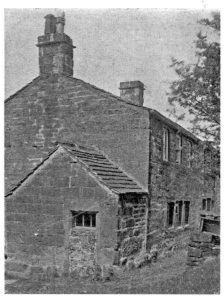

Silver Hill, Wuzzing Stick Holes, 1913
The last farm on the Stanbury side of the Worth is Silver Hill. To the left of the blocked-up doorway are four very obvious holes in the stonework. These are wuzzing holes, which were cut to take one end of a stick. On the other end, a basket of newly washed yarn was attached and spun round to extract the water from the yarn prior to weaving.

3

Schools

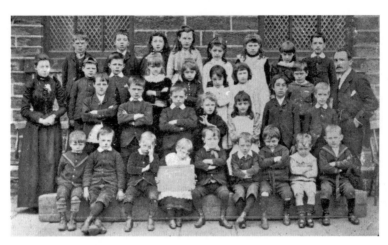

Haworth National School Class, Late Nineteenth Century
This is said to be a Haworth National School class of 1908. However, the
National School closed when the Butt Lane schools opened in 1896. If the
1908 date is correct, this must be a church Sunday school group. The building
is definitely that which housed the Haworth National School. The photograph
is taken at the back of the old schoolrooms in Church Street.

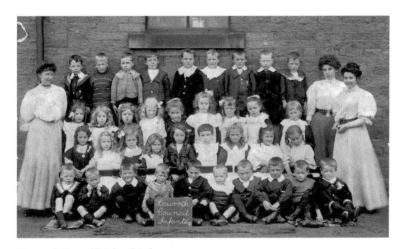

Haworth Council School Infants, *c.* 1900
Around the turn of the century, this group of children was photographed
outside the new infants' school in Butt Lane. Surprisingly, it was taken by
a Blackpool photographer, rather than one of the many who were then in
business in Keighley and Bradford.

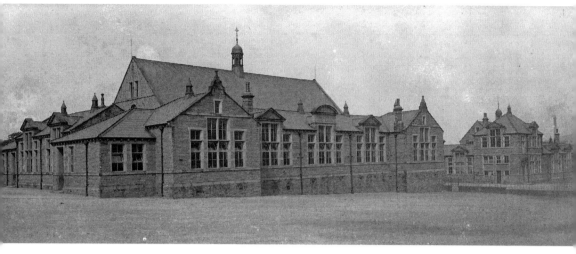

Butt Lane Schools, 1901

The Haworth Central Board schools opened in 1896 under Arthur Hirst as headmaster. He had formerly taught at the Wesleyan Day School in Haworth. The new school had room for all Haworth's children, and the competing Anglican and Nonconformist day schools closed almost as soon as it opened.

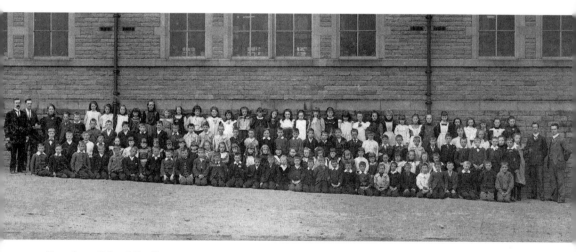

Butt Lane School Pupils, 1901

This photograph of some of the Board school's pupils is one of three similar images that accompanied a petition from the children to Andrew Carnegie. The petition was in support of their parents' appeal to Carnegie for funds for a public library. Haworth is still waiting for a public library.

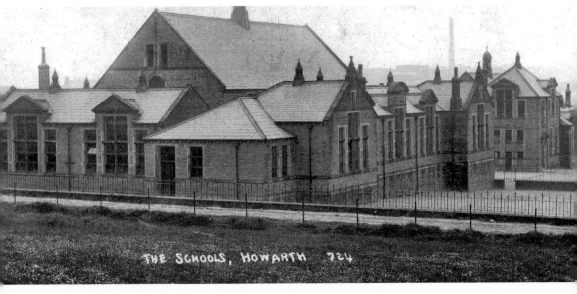

Butt Lane Schools, Early Twentieth Century
The larger building nearest to the camera was the school for the older children. The infants attended the smaller school further down Butt Lane. The misspelling 'Howarth' in the caption was as common a century ago as it still is today.

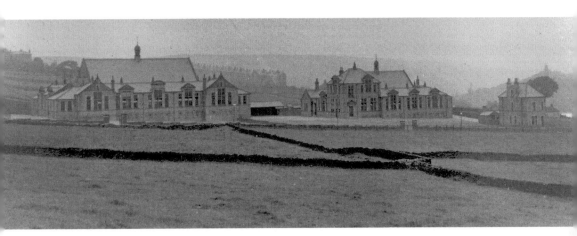

Butt Lane Schools, Early Twentieth Century
A more distant view of the whole school complex, from the main school building on the left to the caretaker's house on the right. The fields in the foreground are those that became Haworth Central Park in 1927.

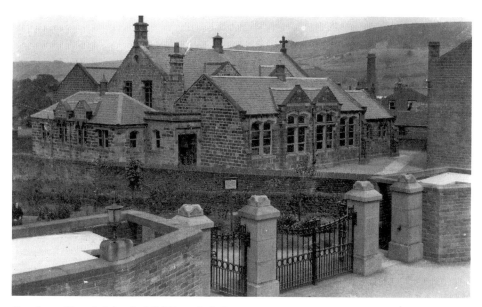

Oxenhope Church Schools, Mid-Twentieth Century
The Oxenhope National School was built in 1846, largely due to the efforts of J. B. Grant, the indefatigable vicar of Oxenhope. The school had to be rebuilt after a fire in 1925. It survived as a school until 1987, when it was converted into private housing, leaving the board school on Cross Lane as Oxenhope's only school.

Old School, Stanbury, Early Twentieth Century
The Stanbury endowed school and its master's house were built in 1805 with money raised by public subscription. The bankruptcy of one of the trustees in 1853 caused the school serious financial difficulties. When the board school opened, the old school had outlived its usefulness and closed down.

Stanbury Board School, 1916
The Board school was established in 1882, with John Riley Sunderland as its first head teacher. He had previously been the master of the endowed school across the road. Sunderland was succeeded as head teacher by Jonas Bradley, who took this photograph, in 1889.

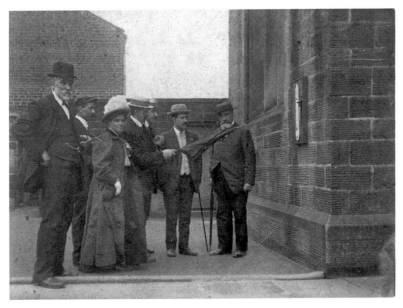

Stanbury Board School, Thermometers, 1908
Jonas Bradley's innovative educational methods, as well as his renown as a local historian, naturalist and Brontë scholar, attracted many visitors to the little village school. Here, a group of visitors – including three from France – examine the school's thermometers.

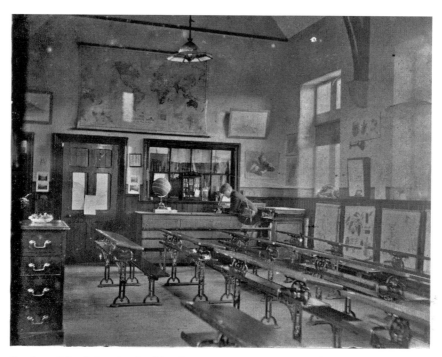

Stanbury School, Interior, Looking East, 1902
The school's classroom as it was in 1902. One of Jonas Bradley's numerous acquaintances is making use of the school's microscope. Bradley was a pioneer of natural history education in primary schools, often taking the children out into the fields and woods to seek specimens.

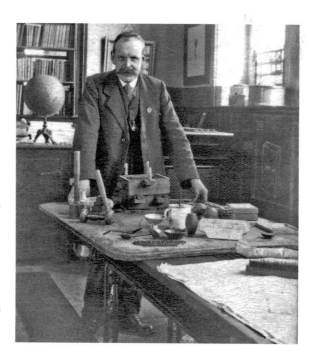

W. H. Meadowcroft at Stanbury School, 1915
Another of Jonas's friends looks as though he is preparing to make some castings in a sand mould. The photograph's caption identifies the man as W. H. Meadowcroft and, tongue-in-cheek, describes him as 'professor of metallurgy'.

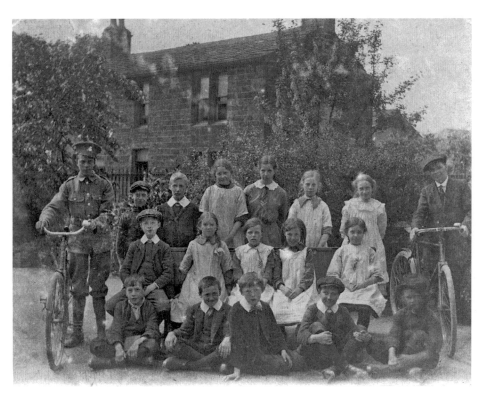

Private Joseph West with Stanbury Children, 1915
Joseph West, a former pupil, looks as though he cannot have left the school very long ago. He is paying a visit to the pupils of his old school on his last home leave before going to the front – a sobering thought. The children are in the school yard with Jonas Bradley's house, Horton Croft, behind them.

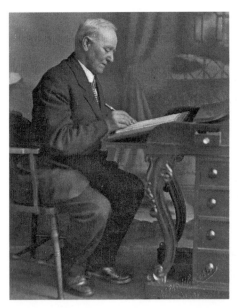

Jonas Bradley, 1925
Jonas Bradley came to Stanbury school as head teacher in 1889, at the age of thirty-one. He was born in Cowling and, after a spell as a pupil teacher, trained at Moray House in Edinburgh. He was a remarkable teacher and he brought international attention to his little village school.

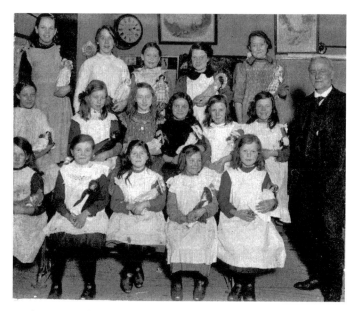

Stanbury School, Girls Who Dressed Dolls, 1914
The school log book entry for 1 December 1914 reads, 'There is a movement on foot in Bradford for supplying Christmas presents to the children of soldiers and sailors on active service. This morning we received twenty dolls to be dressed by the girls attending this school.' Here are some of the older girls with the dolls and Jonas Bradley.

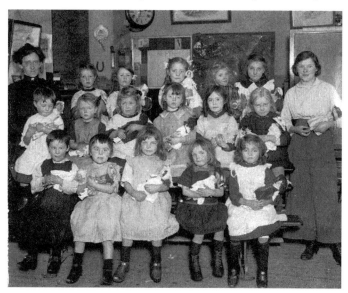

Stanbury School, Children Who Dressed Dolls, 1914
More dolls in the hands of the younger girls. The photographs were taken with flashlight by Mr Dewhirst 'on a muggy day when the gas was lit in the school'. The teacher standing on the left is Mary Sunderland, and the younger teacher is almost certainly Elizabeth Stoney of Haworth.

4

Churches

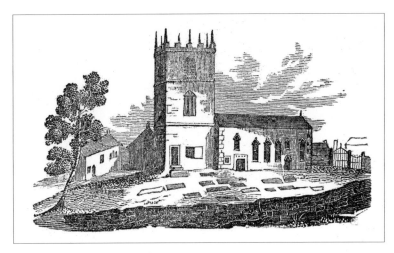

St Michael's from a Hymn Sheet, *c*. 1830
This is the earliest known picture of Haworth parish church. It was used on hymn sheets from about 1830. It is the only depiction we have of the little door in the south wall, which was blocked up in 1838. A new pew was inserted in the gap where the door had been, and the window was made full height to match the others.

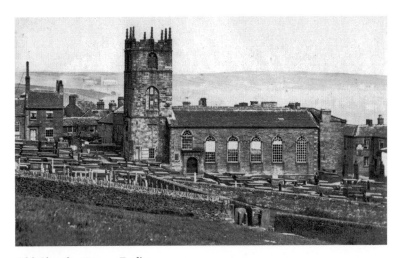

Old Church, 1870 or Earlier
In 1870 the church tower was raised to accommodate the new clock faces. The church is seen here as it was up to 1870. The little door has been removed and the corresponding window now matches the rest. On the left is the Sexton's House.

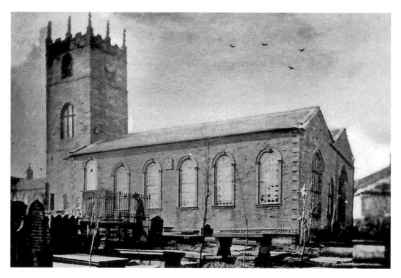

Old Church, 1870 or Earlier
This rather fuzzy image is the only photograph we have of the old clock. This clock was installed by the Revd Isaac Smith in 1729 at a cost of £8. It had only a single face, which was on the east side of the tower so as to be visible from the top of Main Street.

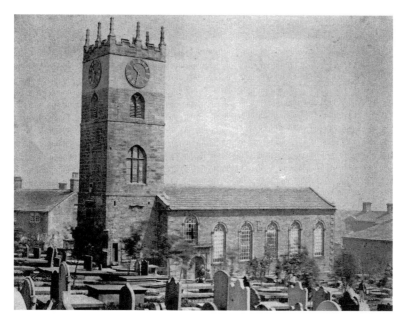

Old Church, 1870s
In the summer of 1870, the church tower was raised by 9 feet to take the four faces of the new clock. This clock was built by J. Cryer of Bingley and cost £256, which was raised by subscription. The newly built section of the tower is very obvious in this photograph.

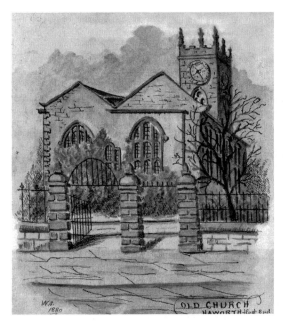

Old Church by William Scruton, 1880
This watercolour drawing of the east
end of the old church, was made
by William Scruton, the Bradford
historian, and is in one of his Brontë
scrapbooks. It was done just after the
old church had been demolished. It
shows very clearly the double roof of
the old building, which gave the gable
end an 'M'-shaped profile.

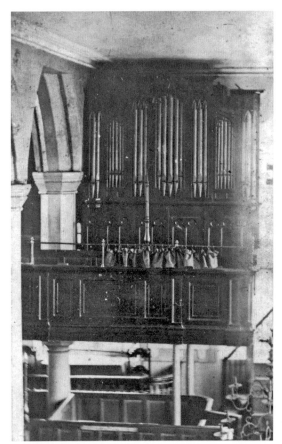

**Old Church, Interior, Organ Loft,
1872 or Earlier**
An internal rearrangement of the
church in 1872 involved the removal
of the organ loft and the re-siting of
the organ in the north-east corner of
the church. Some of the front pews
were also taken out. This photograph
of the organ loft from the west gallery
gives an idea of how cramped the
space between the front pews and the
altar rails was.

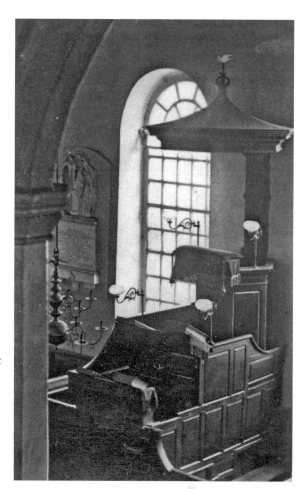

Old Church, Interior, Pulpit, 1870s
The three-decker reading desk and pulpit
was given to the church by William
Grimshaw. It was moved to the middle
of the south wall during the rebuilding
of 1755. This photograph, taken from
the gallery, shows the two reading desks
and the pulpit from which the sermon
was delivered. Over the pulpit is the
sounding board.

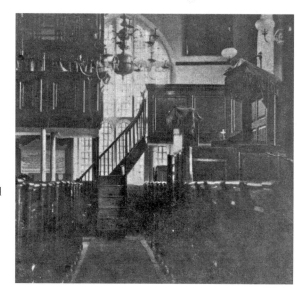

**Old Church, Interior, East and South-
East Galleries, 1872 or Earlier**
To the right of the organ loft is the small
gallery in the south-east corner of the
church, which was built around 1780
for the Lord of the Manor. This was not
welcomed by the holders of the pews
beneath. In 1872 it was removed along
with the organ loft.

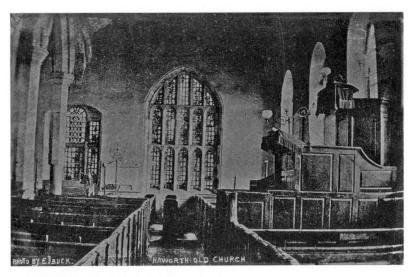

Old Church, Interior, After 1872
This is the east end of the church after the alterations of 1872. The organ loft, small gallery, sounding board and ceiling have all been removed. It is possible that the west gallery was taken down at the same time.

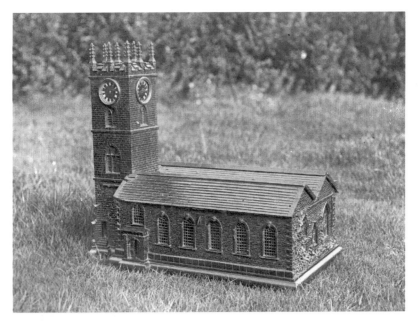

Model of Old Church and Pew Door
Two models of the old church were made out of timber from the old pews. One was sent to America and the other, shown here, is now in Cliffe Castle Museum in Keighley. Unfortunately, it is not usually on display.

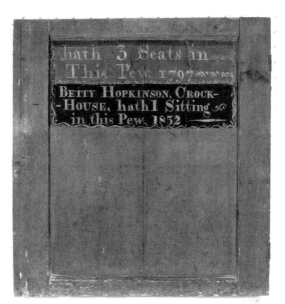

Pew Door from Old Church

Much of the timber removed from the old church, when it was demolished at the end of 1879, was bought by local people. Details of pew-holders were painted on the doors, as in this surviving example. In 1797, Jonas Ogden bought three seats in Pew No. 10 in the North Gallery. Judging by the incomplete inscription, this may be the door to that pew.

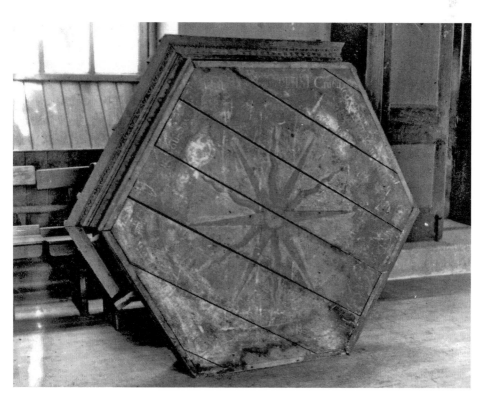

Sounding Board, Grimshaw's Pulpit AD 1742, 1926

As noted above, the sounding board was removed in the 1872 alterations. It is seen here in the old Sunday school in Church Street. It ended its days in a barn in Stanbury, and was eventually burned. It is just possible to make out Grimshaw's name and his two favourite texts (1 Cor. 2.2 and Phil. 1.21) painted round the edge.

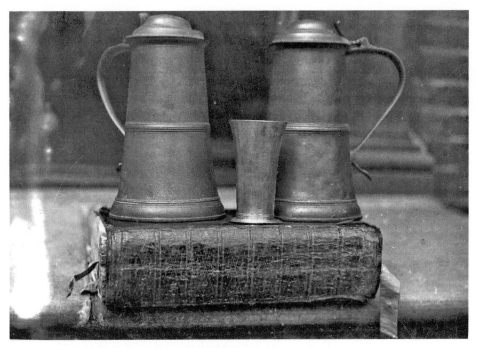

Flagons (1742), Chalice (1593) and Bible (1659), 1926
Amongst the treasures of Haworth church were this seventeenth-century Bible, 'a very valuable
Cup of Silver for the Communion' and Grimshaw's two huge pewter flagons to hold wine for the
great numbers of communicants that his services attracted. The Communion cup and one of the
flagons can now be seen in the Treasury at York Minster.

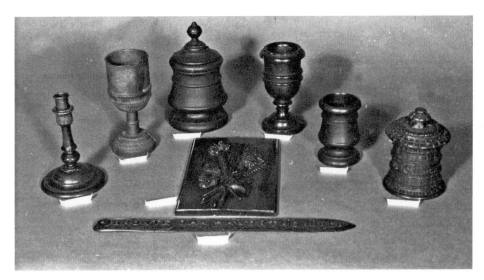

Ornaments from Old Church Timber
Some of the timber removed from the old church was fashioned into ornaments that were
treasured as mementoes of the old building. Here is a selection of those that are in the collections
of the Brontë Parsonage Museum.

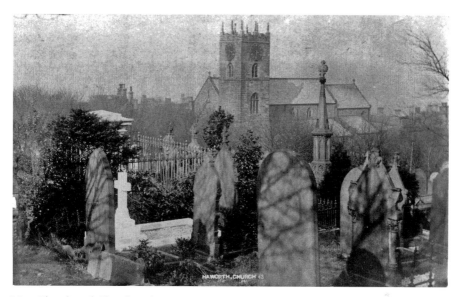

New Church and Churchyard, *c.* 1890

The old church was dark and dank and increasingly unsuitable for use. The Revd John Wade took advantage of the offer of £5,000 from Michael Merrall, and set about the destruction of the old church and the building of the new one. The new church was consecrated in 1881, and is seen here in an early view.

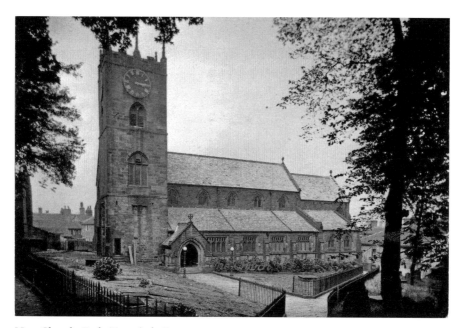

New Church, Early Twentieth Century

The new church, seen from the south, on which side it is surrounded by the oldest parts of the graveyard. Only the tower remains from the earlier building. The tower is of various phases, the base being perhaps 1488 whilst the newest part was added in 1870.

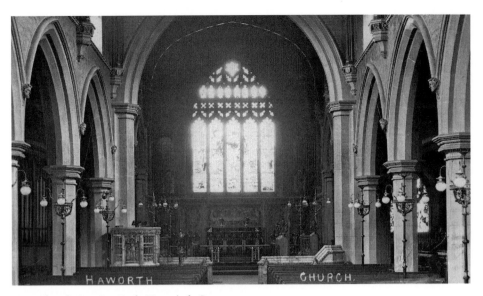

New Church, Interior, Early Twentieth Century
The new church was the recipient of many gifts from the wealthier parishioners and supporters. They included much stained glass and the elaborately carved alabaster pulpit seen here. The church is still lit by gas in this photograph – electric lighting was introduced in 1926.

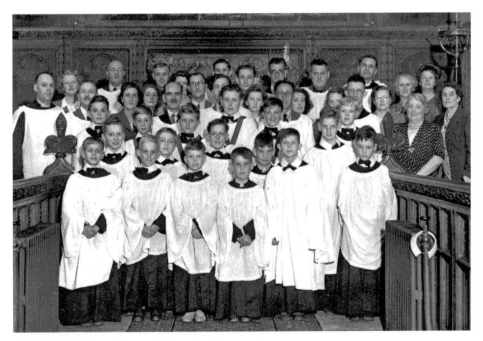

St Michael's Church Choir, Mid-Twentieth Century
The rector of Haworth, Canon Dixon, and the church choir are photographed in front of the carved alabaster bas-relief panel, depicting the Last Supper, beneath the east window.

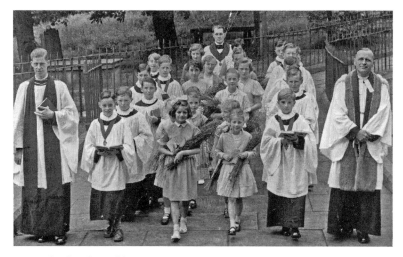

Haworth Church Rushbearing, *c.* 1950
Haworth had an ancient Rushbearing ceremony that was held on the first Sunday after 18 July. It was viewed with disfavour by Oliver Heyworth in the seventeenth century, who complained of feasting, drinking, revelling, rantings and ridings. By the time of this mid-twentieth-century revival, it was a much more decorous affair.

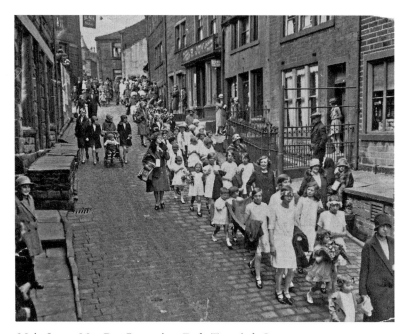

Main Street, May Day Procession, Early Twentieth Century
For many years, Haworth parish church celebrated May Day with a variety of events for the children. Here the May Queen is processing down Main Street with her attendants. They are accompanied by the older children in costume and many of the parents.

Sunday School, Graveyard, 1860s
The old Sunday school in Church Street was built in 1832 with the aid of money from the National School Society. The Sexton's House was built onto the right-hand end of the school building in 1838. The extension on the left was added in 1851. This view across the churchyard looks to have been taken before the trees were planted in 1864.

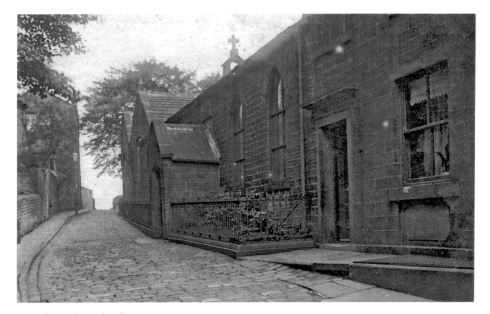

Church Sunday School, 1916
A view up Church Street, in 1916, with the Sexton's House on the right. The unusually good-quality ashlar facing of this house reflects John Brown's trade as a stone mason. The Sunday school building is now complete with the second extension of 1871 at the top end. The railings were taken away for scrap during the Second World War.

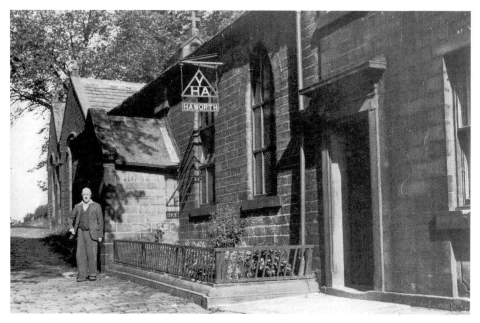

Church Street, Youth Hostel, 1950s
From 1950 to 1958, the old Sunday school was used as a youth hostel, as is evident in this photograph of the period. The Sunday school itself was housed in a much larger building between Church Street and West Lane.

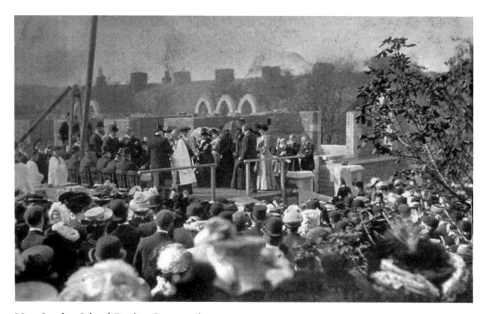

New Sunday School During Construction, 1903
The group in this photograph have gathered to witness the laying of the foundation stone of the new Sunday school, by George Merrall, in May 1903. The very large new school was completed in 1904 on a plot of land behind the old Sunday school.

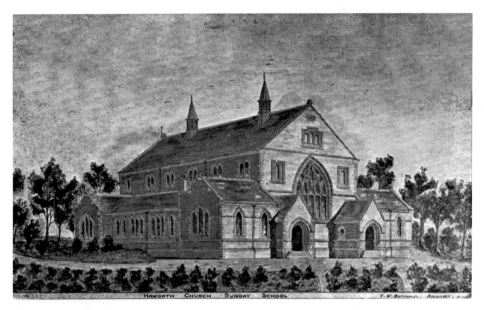

New Sunday School, 1903
The architect of the new Sunday school was T. W. Bottomley, and this is his impression of the finished building. This artist's impression is useful, as the constricted site meant that it was very difficult to photograph the new building in its entirety.

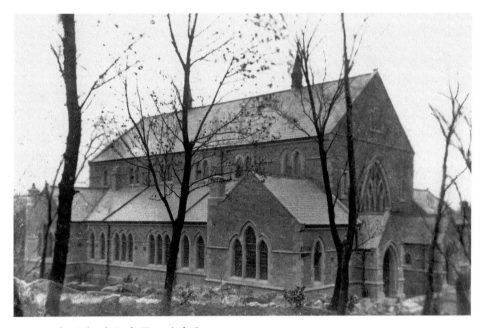

New Sunday School, Early Twentieth Century
The difficulty of getting a photograph of the new Sunday school is apparent in this shot by William Edmondson. He has had to set his equipment up in Church Street and take his picture through the trees in order to get the whole building in.

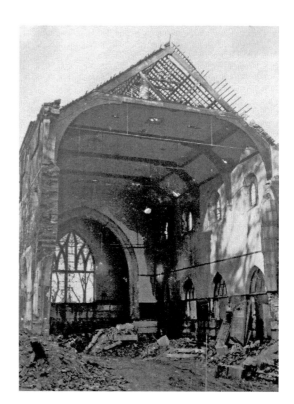

**Haworth Church Sunday School
– Demolition, 1965**
The new Sunday school had a short
life. By the 1960s, it was afflicted
with dry rot and repairs would have
been too costly. Consequently the
Sunday school moved back into the
old building and the new one was
demolished.

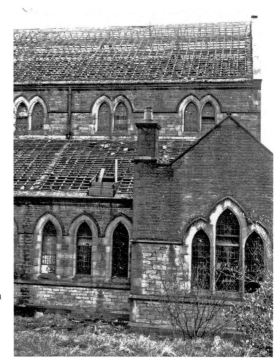

**Haworth Church Sunday School
– Demolition, 1965**
These two photographs of the
demolition of the new Sunday school
were both taken by Jack Laycock.
They give us a clearer picture of the
details of the building than those taken
when it was complete. One of the
arched doorways found an unlikely
new home in the cellar of the White
Lion Inn.

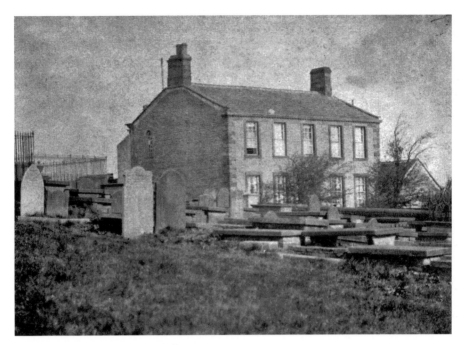

Haworth Parsonage, 1879 or Earlier
The Haworth parsonage was built in 1778 by William Grimshaw's successor John Richardson. It is seen here as it was when the Brontë family lived in it. Behind the house one can just see the end of the old barn in Church Street. The proximity of the graveyard to the house is particularly evident in the absence of the trees that obscure the view nowadays.

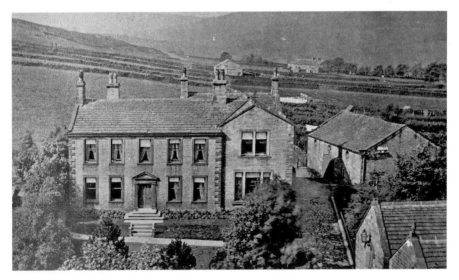

Parsonage from Church Tower, _c._ 1900
John Wade, as well as building the new church, extended the parsonage to accommodate his family in 1878. The Wade extension is the wing on the right-hand side of the building. The old Sunday school is just visible in the right-hand corner. The barn at the end of Church Street was built around 1780, and knocked down in 1903.

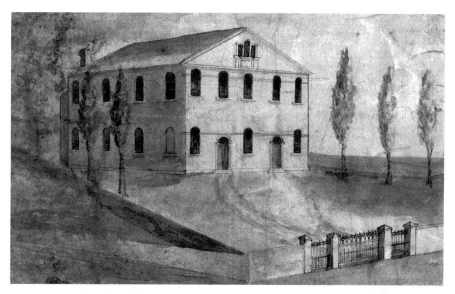

West Lane Baptist Chapel, the 1775 Building, Undated Drawing
It is not possible to be certain, but a number of features suggest that this drawing is of the 1775 Baptist chapel, which was the second on the West Lane site. The original building of 1752 had become unsafe, and was demolished to make way for this larger chapel. When the present chapel was opened in 1845, this building served as the Sunday school, until 1859 when the new school was added to the back of the chapel.

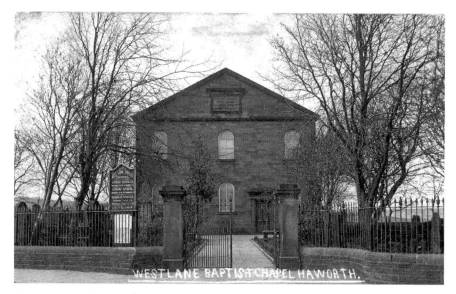

West Lane Baptist Chapel, *c.* 1910
This is the 1845 chapel building pictured during the 'long and fragrant ministry' of the Revd D. Arthur. The large stone panel gives dates for the present building and its two predecessors. Out of sight behind the chapel is the Sunday school, which was built in 1859 and behind that the primary school, which was added in 1909.

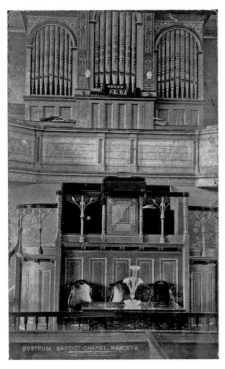

West Lane Baptist Chapel, Interior, Rostrum,
***c.* 1905**
The interior of the West Lane Baptist chapel with rostrum and organ. This organ was played for thirty-three years, by J. Edward Richards, who was appointed organist in 1891 at the age of sixteen. In recent years this has been very considerably altered being now divided into two floors with the chapel upstairs and meeting rooms on the ground floor.

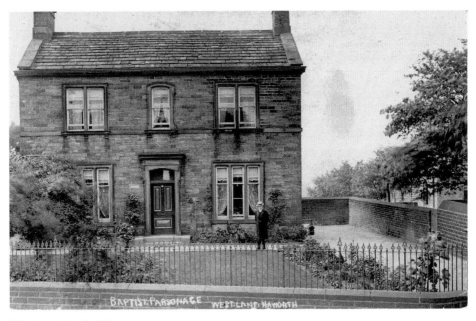

West Lane Baptist Manse, *c.* 1900
The manse on West Lane was built in 1860, during the ministry of the Revd J. H. Wood. The cost of the building was £600. The minister standing in the garden is most likely the Revd David Arthur.

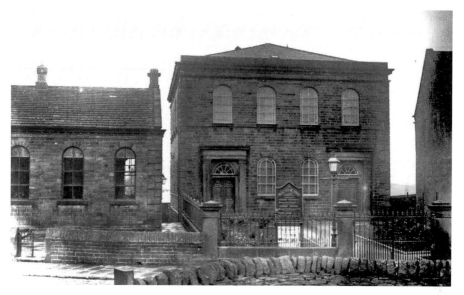

West Lane Methodist Chapel, *c.* 1900
William Grimshaw built a little Methodist chapel here in 1758, but it does not seem to have
seen much use until long after his death. After a number of renovations and extensions, it was
replaced in 1845 by the building seen here. The caretaker's house, which is just glimpsed on
the right, was the original minister's house from 1758.

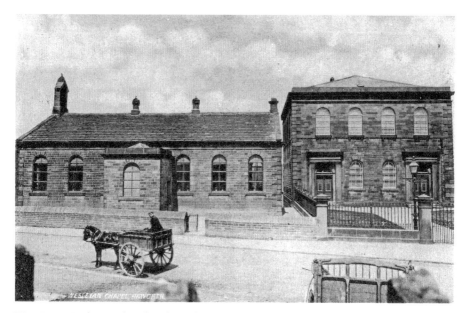

West Lane Wesleyan Chapel and Sunday School, *c.* 1895
This Sunday school building is often said to be that of 1830, but map evidence strongly suggests
that a new building was put up in 1853. The 1845 chapel building was demolished in 1951,
and the Sunday school building has served as chapel and Sunday school since then.

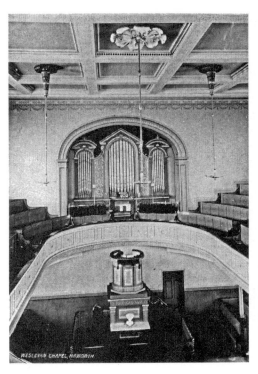

West Lane Wesleyan Chapel, Interior, *c.* 1895
The interior of the 1845 chapel, with gallery, rostrum and organ. The organ was installed in 1847. The ceiling and its ornate rose are worthy of note, as are the splendid gas light fittings.

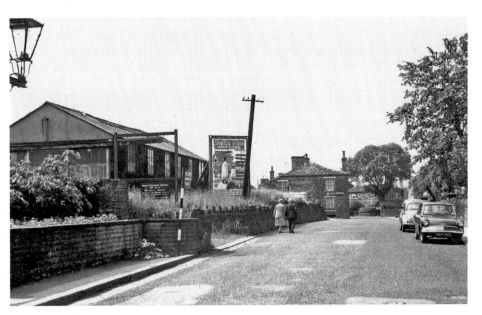

West Lane, Navvy Mission Hall, 1963
The wooden-framed building, on the left of this photograph of West Lane, was the Navvy Mission Hall. Lower Laithe Reservoir was built between 1912 and 1925, the war causing inevitable delay. Surprisingly, the Mission Hall for the navvies working on the reservoir opened in the middle of the war. The opening ceremony was conducted by Alderman W. A. Brigg in May 1916. The missioner was Mr Dennis.

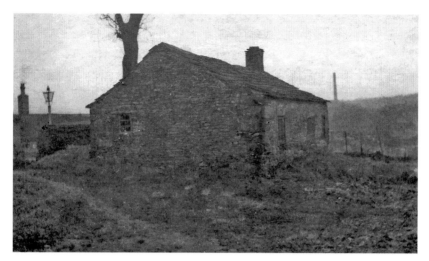

Mill Hill, the Old Primitive Methodist Meeting House, Early Twentieth Century
The Haworth Primitive Methodists first met in this little building at Mill Hill around 1821. It was known as the Old White House and was still standing in 1936. The site can still be seen at Upper Mill Hill, but little if anything of the building remains.

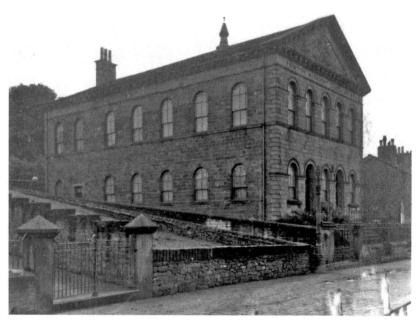

Mill Hey Primitive Methodist Chapel, Early Twentieth Century
In 1836, the Primitive Methodists (or the 'Ranters' as they were sometimes known) bought a plot of land at Mill Hey and built their first chapel. This first chapel was knocked down and replaced by the present building in 1870. An extension was added on the back in 1900. They bought a new organ in 1908, to replace the old 'box of whistles'.

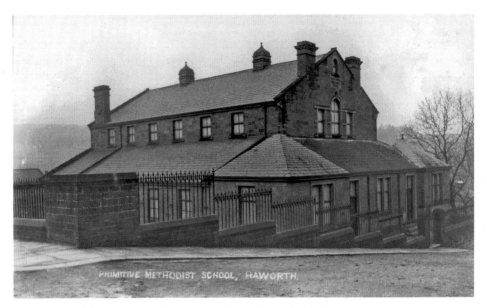

Mill Hey Primitive Methodist Sunday School, Early Twentieth Century
The Primitive Methodists first started a Sunday school at the Old White House in 1835. The rather grander premises in this photograph were built in 1887/88, at a cost of nearly £2,400. The school was on Fairfax Street, some distance behind the chapel. The chapel and Sunday school closed in 1954 after the Primitives amalgamated with the Wesleyans.

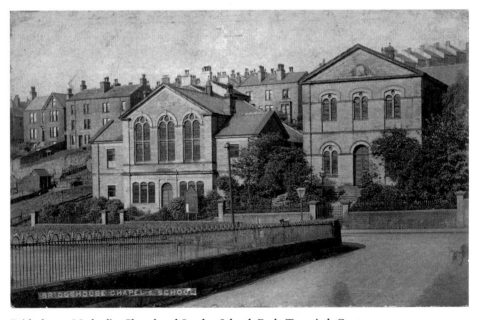

Bridgehouse Methodist Chapel and Sunday School, Early Twentieth Century
The Bridgehouse Wesleyan Chapel, or Richard Shackleton Butterfield Memorial Chapel, was built in 1884 with money given by Frederick Butterfield. The chapel was extended and the Sunday school (on the left) built in 1892. The chapel was demolished in 1964 and the Sunday school a few years later.

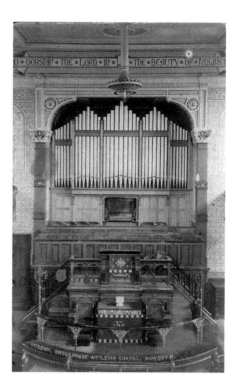

Bridgehouse Methodist Chapel, Interior, Early Twentieth Century
A view of the handsome interior of the Bridgehouse chapel, with its decorated walls and ornate surround to the organ. The gas light fitting is even more splendid than those at West Lane. It was to this chapel that the Mill Hey Primitive Methodist congregation came in 1954.

Hall Green Chapel, Drawing 1900 or Earlier
The Hall Green strict and particular Baptists were a secession from the West Lane Baptist chapel. At first they met in a barn at Bridgehouse, but in 1824 they built a permanent chapel at the top of Bridgehouse Lane. This drawing, from *Pratt's Almanack* of 1902, shows it as it must have looked when new.

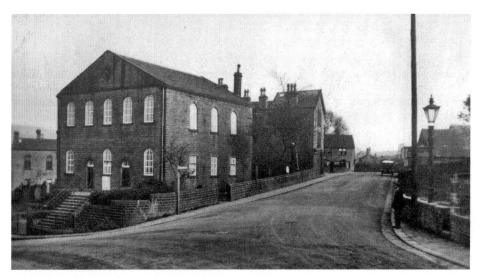

Hall Green Chapel, *c.* 1910

Hall Green chapel was enlarged in 1840 to accommodate vestries and an organ gallery. This photograph shows it as it was at the turn of the century, and there has been little visible change since then.

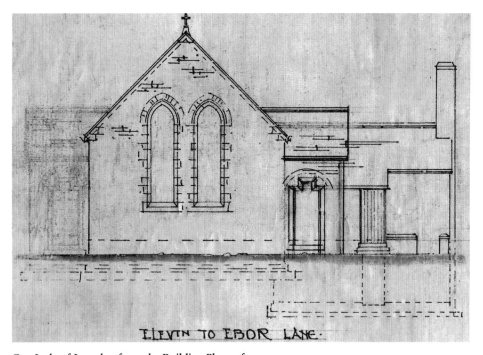

ELEVTN TO EBOR LANE.

Our Lady of Lourdes, from the Building Plans of 1924

The Roman Catholic Church was the last denomination to move into Haworth. In the face of much opposition from the Nonconformists, they managed to buy Craven Royd at the Mytholmes end of Ebor Lane, in 1922. The house serves as the presbytery and the church was built in its grounds. The church opened in 1925, with Jeremiah Twomey as its first priest.

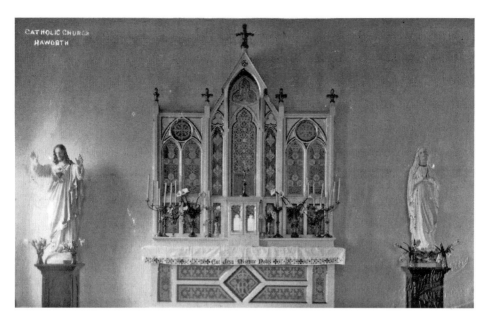

Our Lady of Lourdes, Interior, c. 1930
An early postcard view of the altar of Our Lady of Lourdes. Mass was first said in Haworth in 1917, at the Shepherds' Lodge on Belle Isle. A room over Pedley's draper's shop on Mill Hey was also used. Until 1922, Haworth was served by a priest who came from Keighley on a push bike. Since April 1925 Mass has been celebrated at this altar.

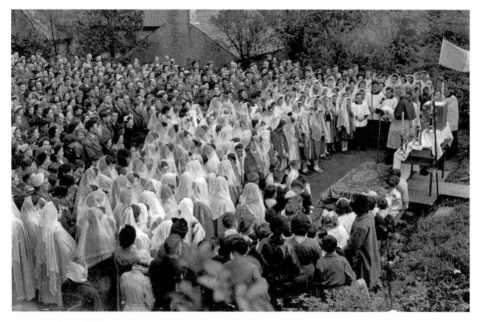

Consecration of Grotto, c. 1954
In the grounds of Craven Royd is a Marian grotto. This photograph shows the large crowd that gathered for the consecration of the grotto in around 1954. The church building is behind them.

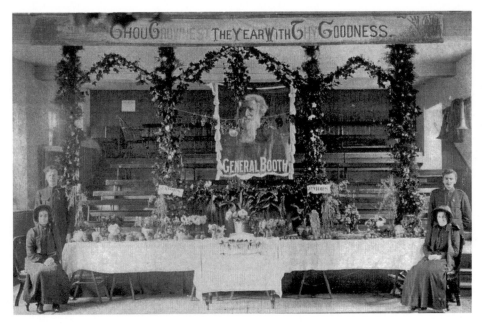

Sun Street, Salvation Army Barracks, Interior, Early Twentieth Century
The Salvation Army opened its Barracks on King Street, off Sun Street, in 1883. Here we have four of the officers at what looks like a Harvest Festival in the old barracks. In 1922, they moved to the old Shepherds' Lodge building on Belle Isle Road.

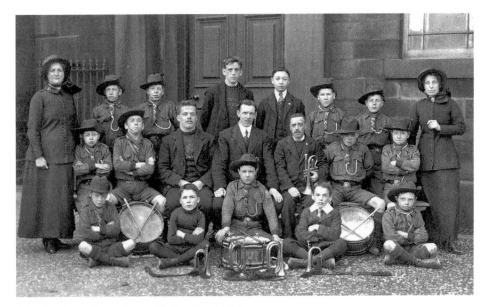

Salvation Army Scout Group, Early Twentieth Century
The Salvation Army had its own Boy Scout and Girl Guide troops. This picture, of the Boy Scouts with their bugles and drums and their leaders, is one of the very few photographs that show the old Salvation Army barracks building. After the army moved to Belle Isle, the building was used as a band mill.

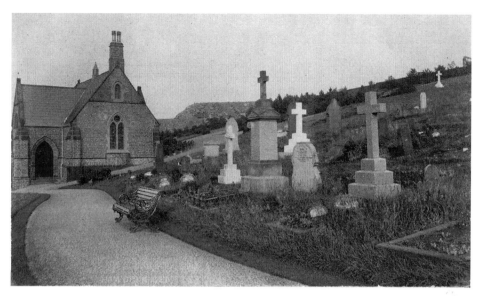

Haworth Cemetery Chapel, Early Twentieth Century

The Haworth parish church burial ground had been viewed with concern as a sanitary menace since as far back as the 1850s. Despite a large extension that decade, there was a pressing need for a new burial ground. The municipal cemetery opened in 1893. Its chapel building survived for less than a century before being demolished by Bradford Council.

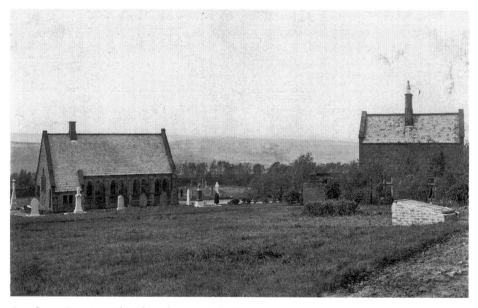

Oxenhope Cemetery Chapel, Early Twentieth Century

Oxenhope had taken the lead in the provision of a municipal cemetery. The first interment here took place in October 1887. Its chapel (*on the left*) was also to be swept away by the council. The cemetery keeper's house is on the right.

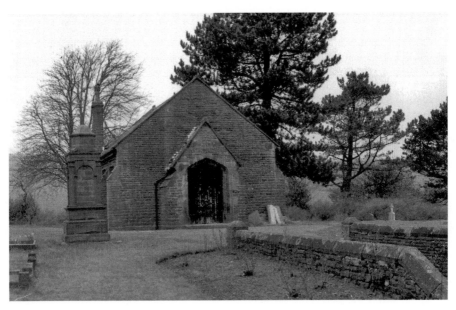

Stanbury Cemetery Chapel, 1988
Stanbury burial ground was opened on Sun Lane in February 1888. The Stanbury cemetery chapel was just one hundred years old when this photograph was taken. It did not survive for much longer. The monument on the left is the Stanbury and Oldfield War Memorial.

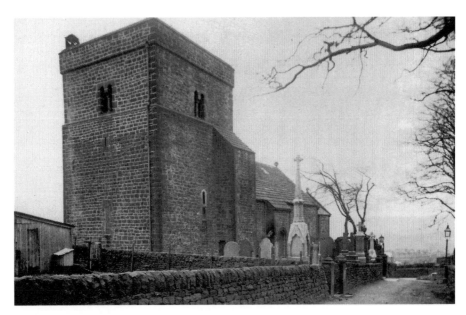

Oxenhope Church, Early Twentieth Century
Oxenhope gained parish status before Haworth did, being created a separate parish in 1847. Its first vicar was Joseph Brett Grant, who worked unremittingly to raise the money to build first the national school, then this church, and finally his vicarage. It was built in 1849 and is remarkably restrained and attractive for a church building of the Victorian age.

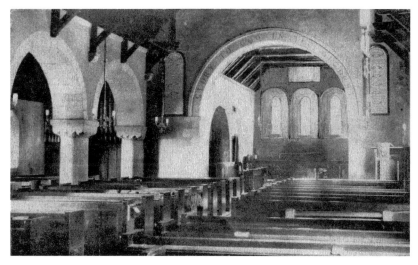

Oxenhope Church, Interior, Early Twentieth Century
The simple early Norman style of Bonomi and Cory's design is also apparent inside
the church. The interior has been sympathetically redesigned in recent years, and is
still well worth inspecting. The chancel arch is lined with particularly attractive tiles,
which bring a touch of colour to the place.

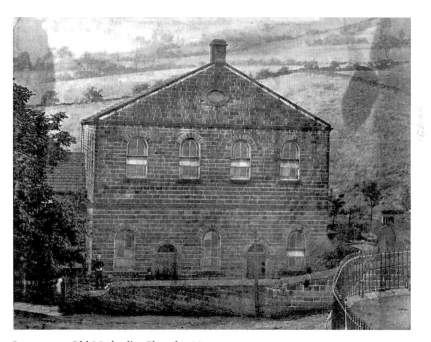

Lowertown Old Methodist Chapel, 1880s
The first Wesleyan chapel in Oxenhope was built at Lowertown in 1805. It was
enlarged in 1824, but by 1889 was too small for its congregation. After the Wesleyan
Methodists moved to the new chapel, this building was converted into Perseverance
Mill, which was used for wool combing. The building was destroyed by fire in 1990.

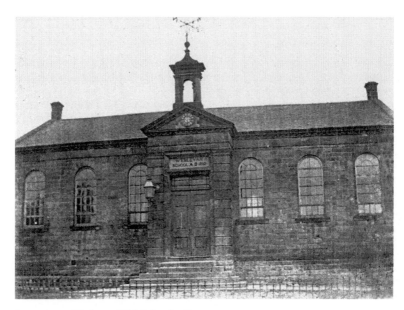

Lowertown Wesleyan Old School, 1890s
The Sunday school was built across the road from the chapel in 1852. It was enlarged in 1877. In 1897 the Sunday school followed the chapel to new premises in Oxenhope. There were two graveyards at Lowertown – one next to the chapel and a newer one behind the school. The school building was knocked down to enlarge the latter.

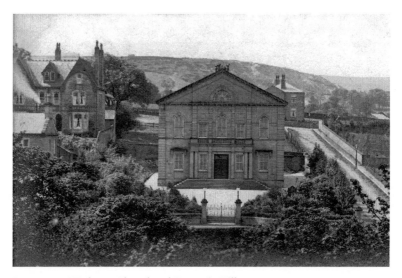

Lowertown Wesleyan Chapel and Fountain Villas, c. 1900
This is the much larger new chapel to which the Lowertown Methodists moved in 1890. This splendid building on Station Road seated 700. Such large congregations were a thing of the past by 1971, when this building was demolished and replaced with a smaller, modern chapel at the top of West Drive.

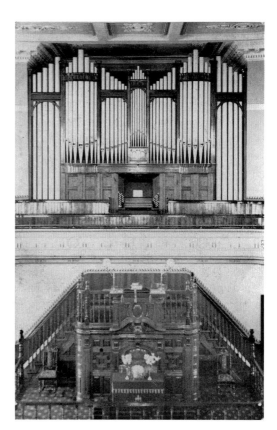

Wesleyan Chapel Oxenhope, Interior, Early Twentieth Century
The familiar chapel pattern, of reading desk below and organ console at gallery level, is seen again in this photograph of the interior of the 1890 Lowertown chapel. A small section of what must have been an impressive ceiling is just to be glimpsed.

Lowertown Wesleyan Sunday School, *c.* 1900
It was to this fine building that the Sunday school children moved from the old Lowertown school in 1897. The day scholars had moved the previous year to the new board school on Cross Lane.

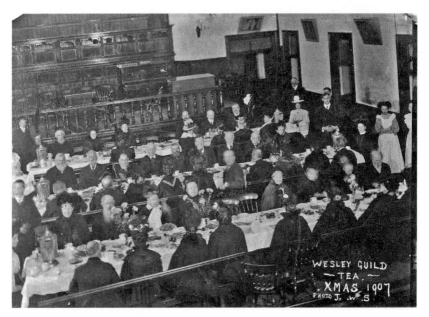

Wesley Guild Tea, 1907
These older people are enjoying a Wesley Guild Tea in what might well be one of the Lowertown Methodist buildings. The photograph came from an Oxenhope source, but is not positively identified.

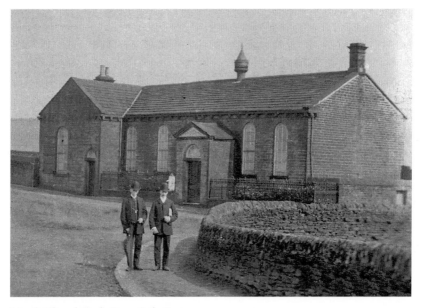

Marsh Chapel, Early Twentieth Century
Marsh Wesleyan chapel had its roots in preaching meetings that were held at Mouldgreave from 1832. The chapel was built in 1836 at a cost of £165, and enlarged in 1874 for £568.

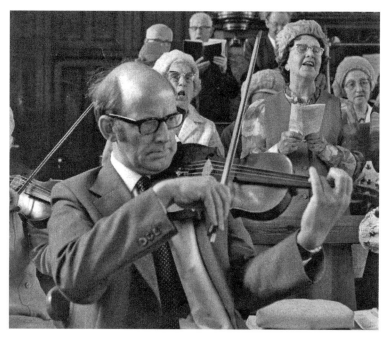

Marsh Chapel Anniversary, 1980s
The hymn-singing at this Marsh Methodist chapel anniversary is clearly much enjoyed. The fiddle accompaniment is something that is not often found these days. Marsh chapel has an organ that can just be seen in the background. It was built by Laycock & Bannister in 1892.

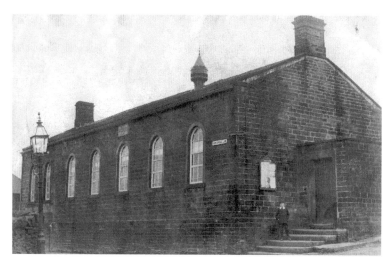

Hawksbridge Old Chapel, *c.* 1900
This, the first chapel at Hawksbridge, was built in 1832 as a preaching station of the West Lane Baptist chapel. Meetings had previously been held at Hill Top and Bodkin Cottage, the site of which is now under Leeshaw Reservoir.

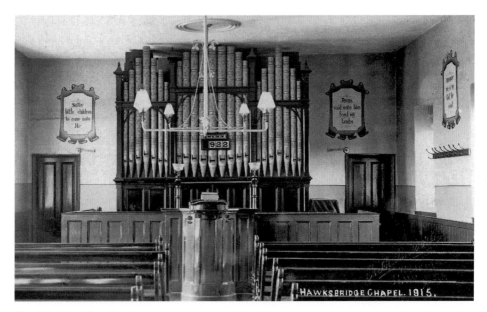

Hawksbridge Chapel, 1915
This is the interior of the old Hawksbridge chapel. At first music was provided by a band – we know that they bought a bass in 1838. Their first organ was a gift from William Greenwood. The organ seen here was installed in 1889. Handel Parker, the composer of 'Deep Harmony', was the first organist here.

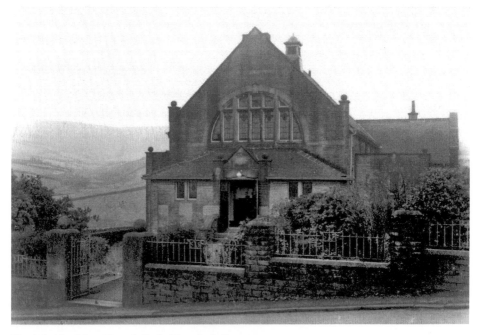

Hawksbridge New Chapel, Early Twentieth Century
The last service was held in the old chapel, 29 August 1915. Services then moved into this new chapel, which was built in 1914/15. The chapel was first licensed for marriages in 1920.

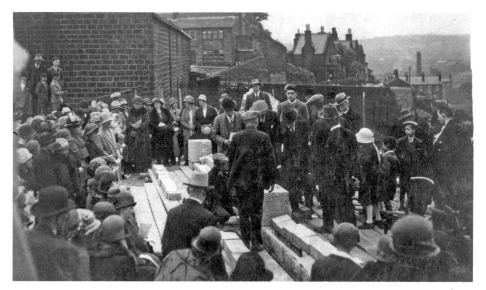

New Oxenhope Baptist Chapel – Foundation Stone, 1926
A crowd has gathered to witness the laying of the foundation stone of the new Oxenhope Baptist chapel at Leeming. The Lamb Inn can be seen in the background, as can a mill chimney, which is down in Oxenhope.

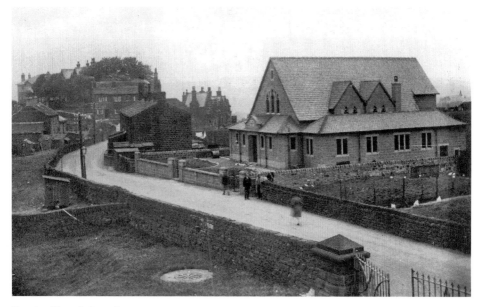

Baptist Chapel, Leeming, 1920s
The chapel was completed the year after building began and opened 21 May 1927. The total cost, including furnishing, was £3,600. Some of the stone is said to have come from the old Horkinstone chapel, for which this was a replacement.

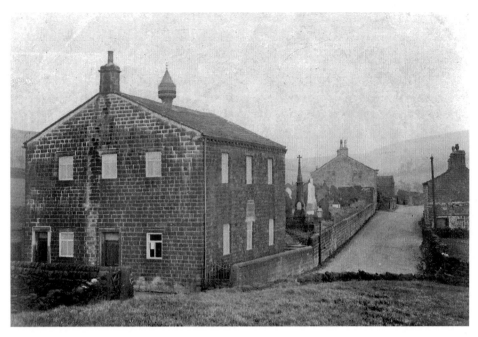

Horkinstone Chapel, Early Twentieth Century
The old Horkinstone chapel stood near the end of Black Moor Road, at 964½ feet above sea level (it had a bench mark on it). It was built in 1836 and modernised in 1871. In 1924, it was declared unsafe and work started on its replacement at Leeming.

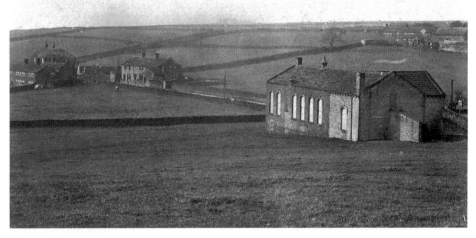

Sawood Chapel, Early Twentieth Century
Sawood Methodist chapel was on the roadside a little higher up than Horkinstone chapel, which can be seen on the left in this photograph. It was built in 1836 and enlarged in 1872. The 1872 extension is clearly discernible here. The hamlet of Sawood itself is three or four fields away, behind the camera.

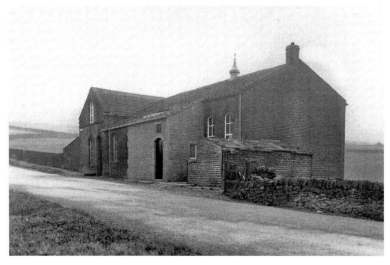

Sawood Chapel, *c.* 1936

This view shows Sawood chapel from the other side on Denholme Road. The
new entrance has obviously been built very shortly before this photograph was
taken. When this chapel closed, around 1951, the congregation moved to the
old Horkinstone Sunday school building at the top end of Leeming village.

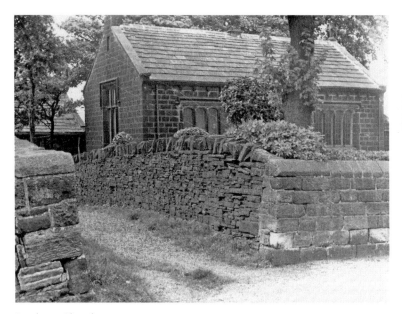

Stanbury Church, 1963

The little mission church at Stanbury was built in 1848 as a church school
with money from private subscriptions, collections at Haworth parish church
and from the National Society. It owes its existence largely to the efforts of
Arthur Bell Nicholls. For the first 150 years, it was simply Stanbury Mission
Church, but in September 1998 the Bishop of Bradford gave it its new name
– St Gabriel's, Stanbury.

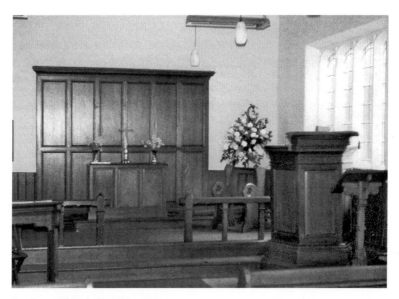

Stanbury Church, Interior, 1960s
The pews have been removed since this photograph was taken, but little else has altered. The most notable feature of this interior is the pulpit. It is the top part of the old three-decker pulpit from Haworth old church. It was from this pulpit that William Grimshaw delivered his sermons. It was also used by the Wesleys and other leaders of the evangelical revival.

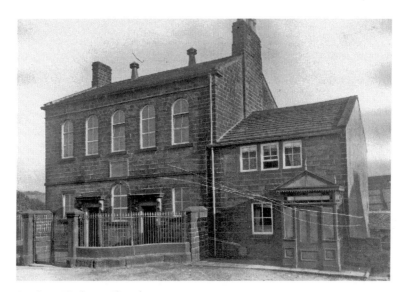

Stanbury Wesleyan Chapel, *c.* 1910
The Stanbury Wesleyan chapel had its origin in a class formed by Joseph Craven in 1811. A prayer meeting was started around 1830 and the chapel building followed in 1832. It was raised in height to accommodate a gallery in 1845. A further extension was added at the back in 1860, and the caretaker's house was probably added at the same time. The chapel closed in 1966 and was converted to housing in 1978.

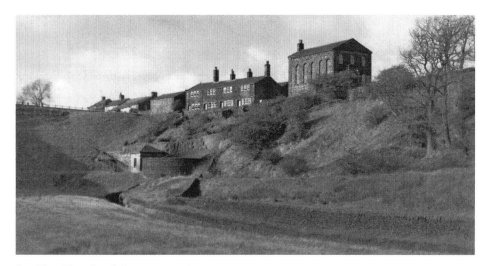

Scar Top Chapel and Cottages, 1968

The south and east walls of Scar Top chapel are seen in this general view of Scar Top. The bank on the left is the embankment of Ponden Reservoir, and the round structure at the foot of the hillside is part of the system for releasing water from the reservoir. Strictly speaking, Scar Top is just outside Haworth township, but it is generally regarded as a Stanbury institution.

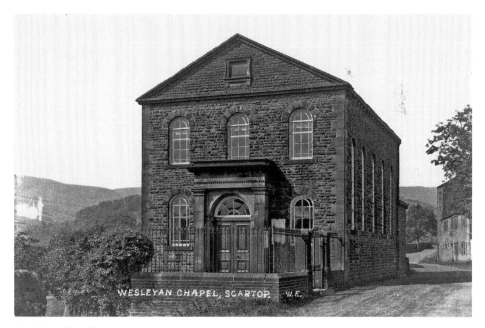

Scar Top Chapel, *c.* 1900

Despite the caption on the photograph, Scar Top was an undenominational rather than a Wesleyan chapel. It is because of a dispute between these two factions that the date stone is blank. Scar Top started as a Sunday school in 1818 but this building was erected in 1869.

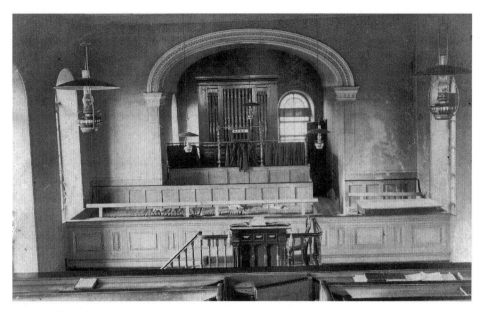

Scar Top Chapel, Interior, *c.* 1900
Much of the chapel woodwork was replaced in 1891. The organ was installed in 1902, the gift of
Joseph Green of Keighley. The chapel was still lit by oil lamps, which are very clearly seen in this
photograph. Acetylene gas lighting was introduced in 1909 and electric lights in 1946.

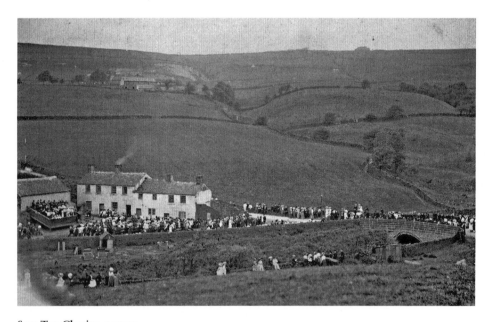

Scar Top Charity, *c.* 1900
Scar Top is best known for its anniversary or 'Charity' held on the second Sunday in June. This
continued to be held in the open air, whenever possible, for longer than any other chapel charity
in the area. There was no suitable site near the chapel, so the Charity was held down at Ponden
corn mill.

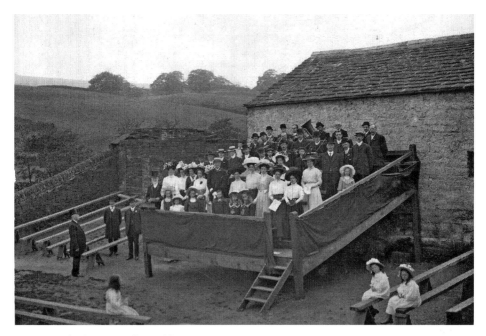

Scar Top Charity at Ponden Bridge, *c.* 1900
The musicians, choir and speakers used this stage – erected against the old corn mill wall. There were two services: one in the afternoon and one in the evening. The Scar Top Charity was well known as a trysting place of the younger people, hence its informal name 't'coppin' on charity'.

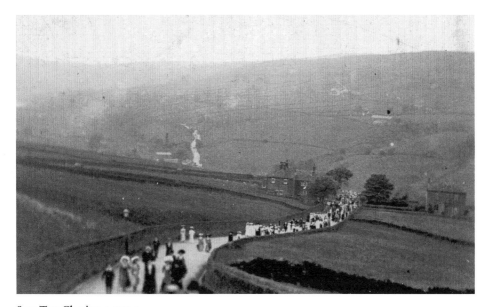

Scar Top Charity, *c.* 1900
Crowds of people make their way up Hob Lane, past the Eagle Inn, towards Stanbury, after another year's Charity. The original photograph is tiny but the 'Sunday best' finery is still evident in this picture.

5

Leisure

Church Gates, Haworth, 1933
Leisure at its simplest: two of Haworth's older inhabitants have paused for a talk and a smoke on the church steps. The top of Main Street was one of the gathering places for the older men of the village well within living memory.

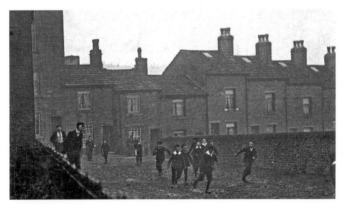

Boys Playing in Minnie Street, *c.* 1900
It is surprising to find such an early photograph of an energetic scene of boys at play in the street. The street in question is Minnie Street, which is obviously still unsurfaced. The street running across the end of Minnie Street is Prospect Street. The three-storey building on the left in Prospect Street is the Oddfellows' Hall and one of the cottages under it.

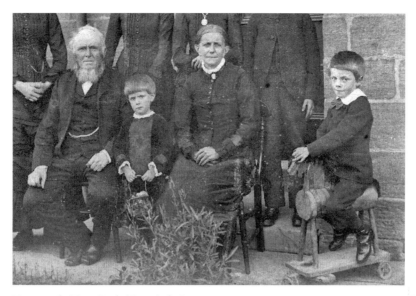

Homemade Toys, Early Twentieth Century
This unidentified Oxenhope family gives us a chance to see an example of a homemade toy. The older boy on the right is sitting on a wooden horse on wheels, which has been made out of a log and some wooden board. His younger brother looks to be holding a basket of flowers.

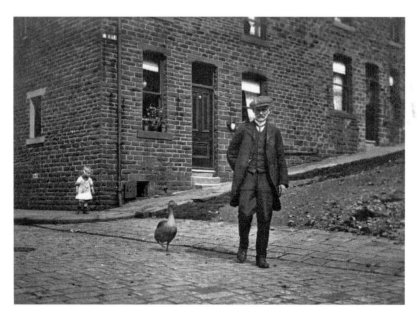

William Smith with Pet Goose, May Street, Early Twentieth Century
Cats and dogs were presumably as common in Haworth a century ago as they are now. Geese were presumably rarer pets. William Smith was a forty-four-year-old warp dresser in 1901. He lived on Haworth Brow, at 5 May Street, which is the house behind him in this photograph.

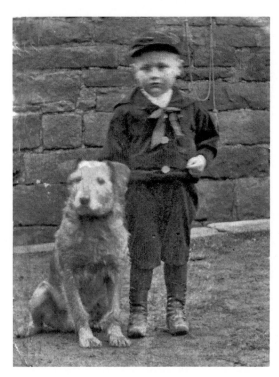

Arthur Parker and Nell, *c.* 1903
Here is one of Oxenhope's dogs. Nell
is seen with the young Arthur Parker
of Uppertown, Oxenhope. Arthur
was born in 1900 and died in 1981.
He was a descendant of the famous
tenor Thomas Parker. He is buried
in Oxenhope cemetery with his wife
Grace Ann.

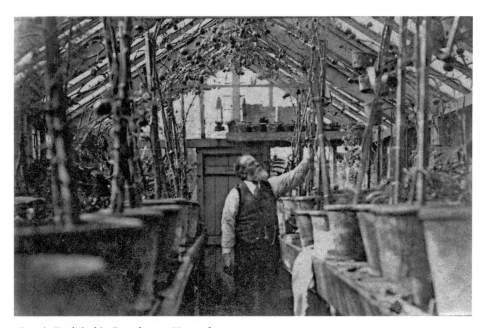

'Counie Fred' in his Greenhouse, Haworth, 1907
Unfortunately, the man known as 'Counie Fred' remains unidentified. However, he was clearly a
dedicated tomato grower. This is one of the photographs of him in his greenhouse, which were
taken by Jonas Bradley. The location of the greenhouse is also unknown, but many were on
Haworth's various allotments.

Joseph Pighills, Oxenhope Artist, *c.* 1980
The Haworth area has had its share of artists, but none is better known than Joe Pighills. He worked in many media, and many different styles, but is best known as a landscape painter in watercolours. His recipe for an Oxenhope moorland sky was 'nobbut a bit o' mucky watter'. When he was asked why he never painted a blue sky, he replied 'ultramarine's *varry* expensive'.

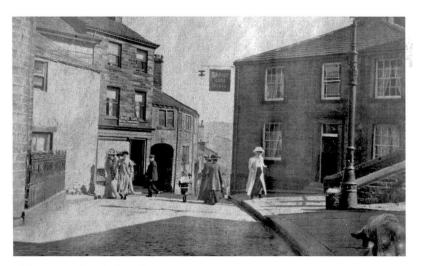

Visitors near the Black Bull, *c.* 1910
A party of visitors making their way up towards the Brontë Society's Museum. The Brontë Café, on the left, and the Black Bull, on the right, were there to provide for them with food and drink. In 1931 the Bull catered for Max Beerbohm and Thomas Hardy's widow who had been visiting the Parsonage Museum.

West Lane, Brontë Museum Entrance, *c.* 1910
Literary visitors started coming to Haworth in the 1850s. The Brontë Society's first museum opened above the Yorkshire Penny Bank in 1895. The museum and church were the main destinations for visitors, as the parsonage was then private. Here, two visitors are entering the side door, to climb the stairs to the museum's room above the bank.

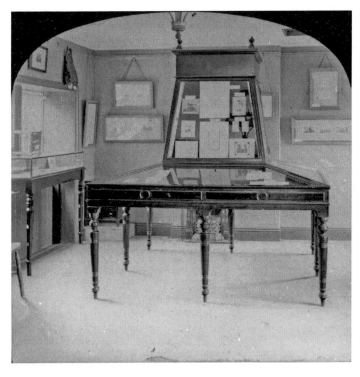

Old Brontë Museum, Interior, Early Twentieth Century
This is the museum that visitors found at the top of the stairs. The Brontë Society's collections were already significant as they had been buying manuscripts and possessions of the Brontë family as opportunities arose. The collections were to be greatly augmented by the gift of the Bonnell Collection in 1926.

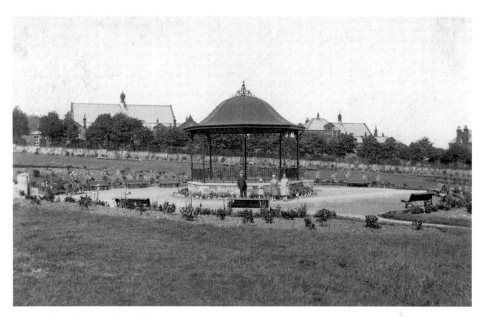

Haworth Park – Bandstand, 1920s
Haworth Central Park was made on seven acres of land bought from the Emmott-Rawdon estate. Some of the work was done by unemployed men to provide them with some income. The bandstand was a central feature of the park, which was used for a variety of events. It was declared unsafe and was taken down probably sometime in the 1970s. The stone base was dismantled in February 2011.

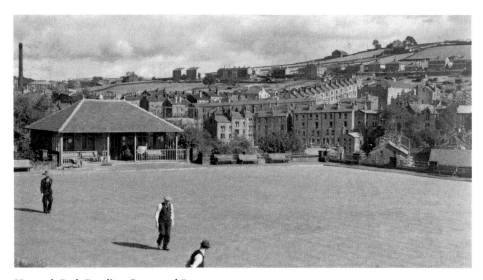

Haworth Park Bowling Green and Brow, 1930s
The idea of a bowling green in Haworth Park was taken up shortly after the park opened. There were many delays, both in the planning and the execution of the plan. The bowling green was finally opened on Coronation Day in 1937. The Haworth Bowling Club was charged three shillings per match to use the green.

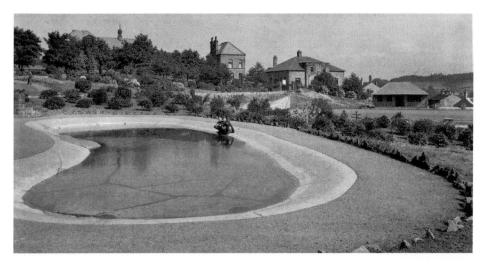

Haworth Park Paddling Pool, Mid-Twentieth Century
This is the original kidney-shaped paddling pool in the park. The idea of rearranging it was first mooted by the council in 1928. This seems to have taken some time, as it had not happened when this photograph was taken some time after 1937. By the mid-1950s, the paddling pool was rectangular in shape. It has now been filled in.

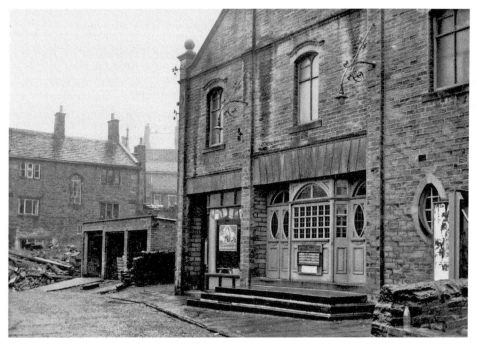

Hippodrome Cinema ('Old Pictures'), 1961
Pearson and Cryer applied for permission to build an Electric Picture Hall on Belle Isle Road in 1912. The Hippodrome opened the following year. A 1915 proposal to build a picture house on the site now occupied by Spar, on Station Road, came to nothing. Haworth's second cinema, The Brontë Cinema, opened on Victoria Road in the early 1920s. Both had closed by 1961.

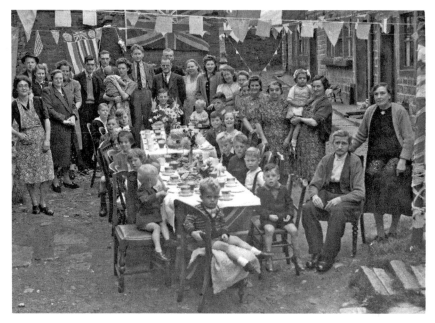

Hird Street, Victory Party, 1945
The end of the Second World War was celebrated throughout the area – as it was throughout the country. Here is Hird Street's celebration party, which was held on 9 September 1945. This was probably the first and last time that a Soviet flag was flown in Hird Street!

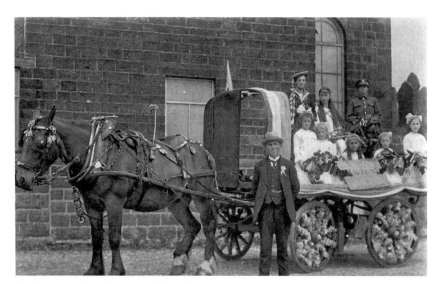

Horkinstone Chapel, Peace Celebrations 1918
Victory in the 1914–18 war was also marked by public celebrations. This decorated float, with boys in army and navy uniforms, and a girl perhaps representing peace, is at Horkinstone chapel, above Leeming. A poster in the chapel window announces a celebration of which this was no doubt part.

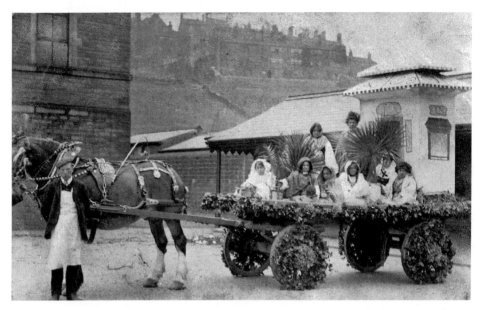

Procession Float, Butt Lane Schools, 1905
Local tradesman had been providing horse-drawn carts for use in local celebrations long before the First World War. This gala float, which might represent some Biblical scene, was photographed in 1905. The building is the senior school and the street in the background is Moon Street.

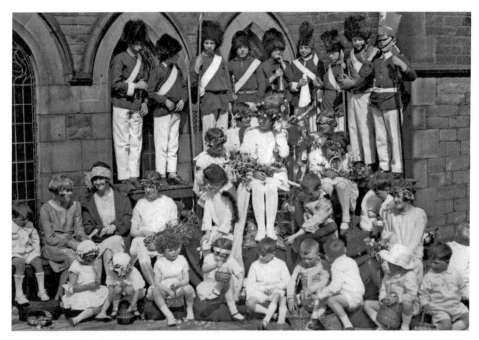

New Sunday School May Day Celebrations, Mid-Twentieth Century
The church's May Day celebrations have been mentioned above. Here we see the May Queen and her attendants outside the new Sunday school building. The costumes varied from year to year – here the boys are dressed as guardsmen.

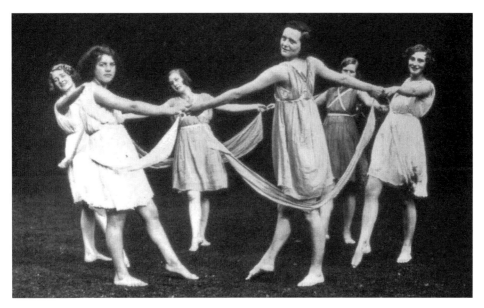

May Day Celebrations, Girls Dancing, *c.* 1930
Another scene from the May Day celebrations. The girls are dancing on the rectory lawn. Third from the left is Marie Sutcliffe who was to marry David Hird who served as the church's organist for many years.

West Lane Baptist Chapel Field Day, 1955
The other denominations also organised days of children's events. West Lane Baptist chapel members walked round the village, led by the Haworth Prize Band, on Whit Mondays. These girls are playing in the Redman Memorial field, near the chapel, after one of the last of these walks around 1955. It is not clear what the boy reclining on the table in the background is doing.

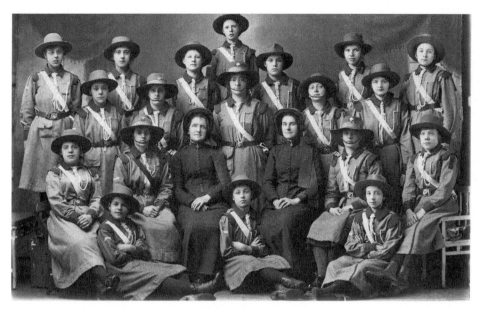

Salvation Army Girl Guides, Early Twentieth Century
We have already seen the Salvation Army Boy Scout troop above. The Army also catered for girls. Here are the Salvation Army Girl Guides, presumably photographed in the barracks. The size of the group is some indication of the level of support that the Salvation Army enjoyed in Haworth earlier in the twentieth century.

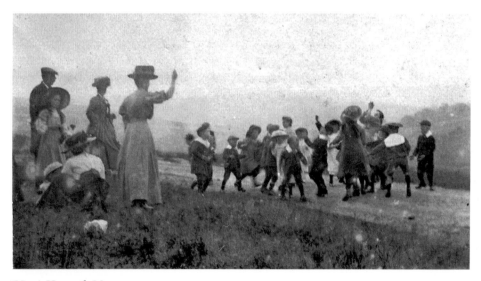

'Nuts', Haworth Moor, 1910
The Keighley Cottage Homes on Nashville Street were opened in 1906, by the Keighley Workhouse Guardians, to house about forty children. The children from the homes were given a day out in Haworth in July 1910. Here they are scrambling for nuts thrown by the adults. Apart from nut scrambling, the children ran races, skipped and had a tug-of-war.

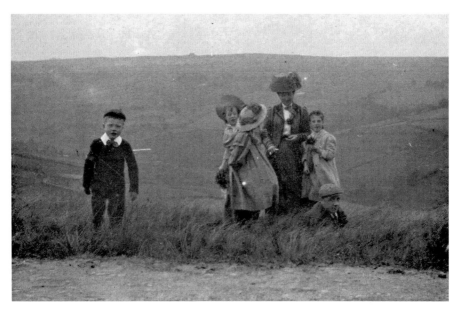

Mrs Binns and 'Nippers', 1910
'1920's Boy' Stanley Boardman described the 'Cottage Homers' as wearing coarse grey uniforms and boots. The regime looks to have been less harsh in 1910 if this photograph is anything to go by. The children are pictured with Mrs Binns somewhere on Cemetery Road in Haworth.

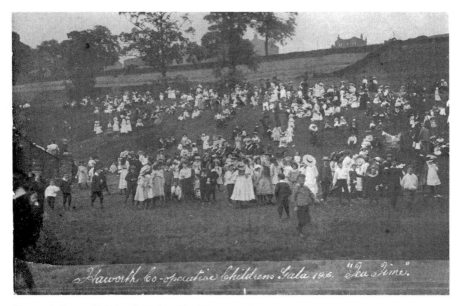

Haworth Co-op Children's Gala – Tea Time, 1906
Apart from the churches and chapels, the local Co-operative societies seem to have been the principal organisers of children's festivities. The location of this 1906 Haworth Co-op Gala is uncertain..

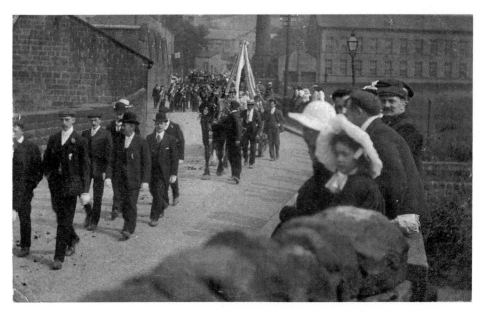

Gala Procession, Lowertown, *c.* 1900
This is most likely the Oxenhope Co-operative Society's Gala procession, which, having started at Leeming, is making its way along Station Road at Oxenhope. The gala queen is on the horse-drawn cart. A brass band (presumably Haworth's) can be seen by the weaving shed on the left.

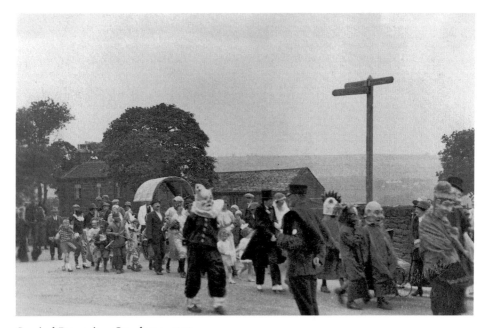

Carnival Procession, Oxenhope, 1912
This quite odd-looking fancy dress procession is in Uppertown, Oxenhope. The wooden signpost identifies the place as the junction of Shaw Lane and Hebden Bridge Road. Papier mâché heads of this kind were found in an old Oxenhope house some years back.

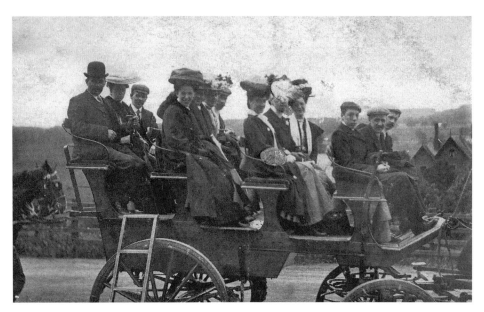

Charabanc Trip, Early Twentieth Century
The horse-drawn charabanc allowed groups from chapels and workplaces to take trips out into the countryside. This is an Oxenhope group on an outing. We know that the first person on the front row is Sim Peacock, but the location is not known.

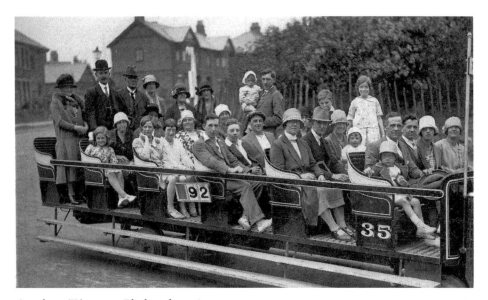

Oxenhope Trippers at Blackpool, 1928
When the internal combustion engine was applied to the charabanc much more distant destinations were brought within range. These Oxenhope folk are on a trip to Blackpool. They are enjoying a circular tour of Blackpool in a 1926 Shelvoke & Drury chara from the Blackpool bus fleet – this is not the chara that brought them from Oxenhope. Notice the photographer's identifying number, 92, to facilitate orders for prints.

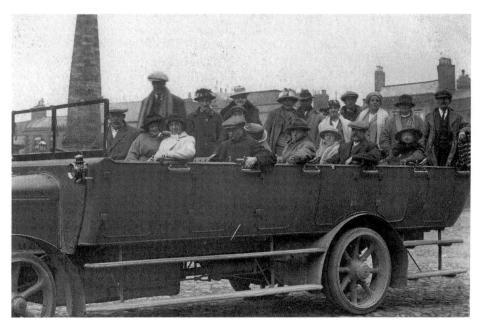

Charabanc Trip at Richmond, 1930s
Other groups headed off for the Yorkshire Dales. Ratcliffe's 'Pride of the Valley' has brought this group to Richmond in Swaledale. This destination may have been chosen because many unemployed Swaledale lead miners had moved into Haworth in the 1890s. The Brontë Bus Company were still running trips to Reeth show in the 1960s.

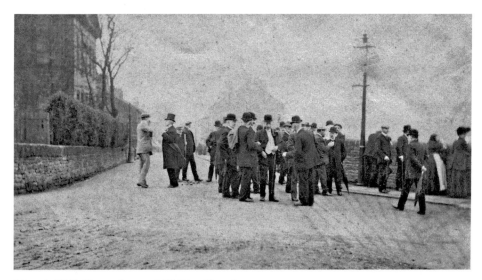

Masonic Hall, Haworth, near Mill Hey Chapel, 1907
Freemasonry has a long history in Haworth, the Prince George Lodge having first met here in 1796. The Three Graces Lodge moved from Barnoldswick in 1806. For a long time they met at inns and in rented premises in the village. In 1907 they built their present lodge on Mill Hey. Here, the members of the lodge are gathered for the laying of the foundation stone.

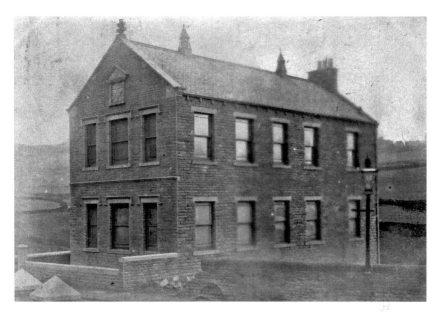

Masonic Hall, Haworth, 1908
This is the newly erected lodge in 1908. The double cross on the gable belongs to the Plains of Mamre Knight Templar Preceptory. The date stone has the monogram 'TG', of the Three Graces Lodge, and the date 1907. The ground-floor windows have since been blocked to cut out traffic noise.

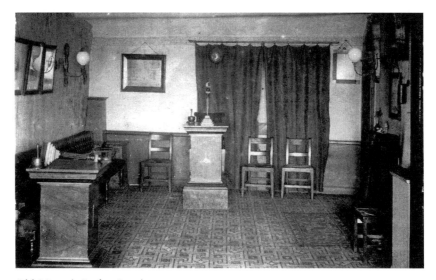

Old Masonic Lodge, Interior, *c.* 1900
This is the 'private Lodge Room' in Newell Hill where the Three Graces Lodge met from 1833 until 1907. The masons celebrated their move to Newell Hill with a procession to the church in regalia followed by a dinner, masonic songs, toasts, etc. Newell Hill has been called Lodge Street since the 1880s.

Grand United Order of Oddfellows

VICTORIA HALL, HAWORTH,

Oddfellows' Hall, Drawing 1900 or Earlier
There were a number of Friendly Societies in Haworth. Two of them built premises of their own – the Shepherds on Belle Isle Road and the Oddfellows on Queen Street. Below the Victoria Hall, which is seen in this image from *Pratt's Almanack* of 1902, are three cottages in Prospect Street that belonged to the Oddfellows.

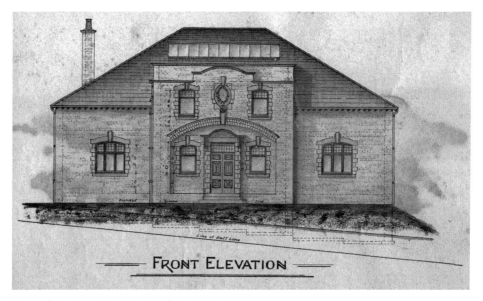

— FRONT ELEVATION —

Haworth Institute Butt Lane, Architect's Drawing, *c.* 1920
Haworth Mechanics' Institute, which was formed in 1848, provided a reading room and library as well as organising lectures and evening classes. The institute closed in 1898. When it became obvious that the proposed public library was not going to materialise, the new Public Institute was opened in 1925.

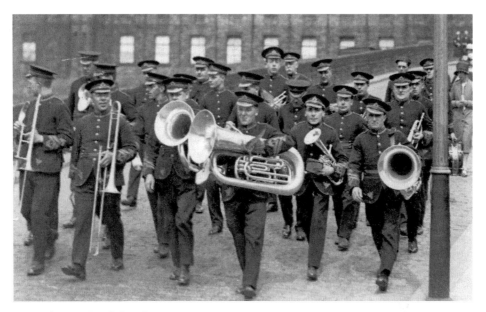

Haworth Brass Band, Lees Lane, 1930s
The Haworth brass band had its real origins in a band organised at Springhead Mills by Hartley Merrall who had encountered a group of brass players busking. This was in 1860 or thereabouts. Here they are walking at the head of a procession down Lees Lane.

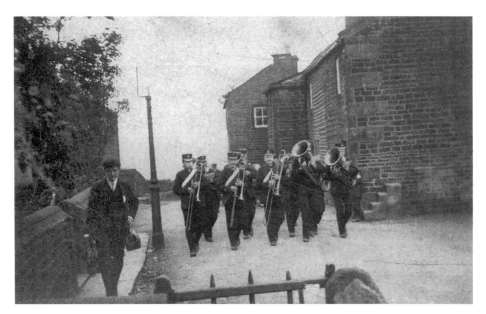

Haworth Band in Stanbury, Early Twentieth Century
This is a rather earlier photograph of the Haworth brass band in Stanbury. The man on the left, carrying bags, is by the Manor House gate. The Haworth band has had its ups and downs over the century and a half of its existence. Because of its lack of solid financial support, it was once referred to as the 'bread and cheese band'.

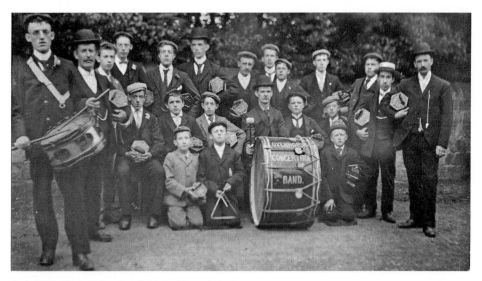

Oxenhope Concertina Band, Early Twentieth Century
The brass band survives, but concertina bands have vanished. They used to be numerous in Yorkshire but none survive. Here is the Oxenhope concertina band at an unknown location. Like a brass band they have a small percussion section, drums and triangle in this case. Unusually, their instruments are 'push-pull' Anglo concertinas. The fully chromatic English concertina was more usual in bands.

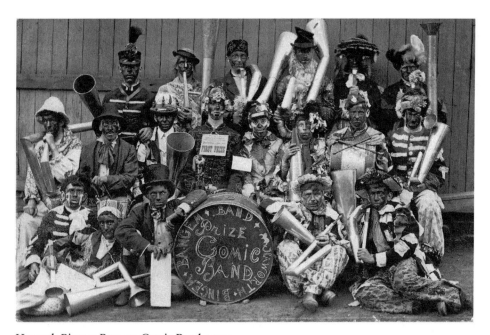

Haworth Bingem Bangem Comic Band, 1905
Comic bands generally adopted fanciful names such as Keighley's Wiffen Waffen Wuffen Band or, as here, Bingem Bangem Band. The musical standards were presumably not of the highest order, as their instruments, despite their size, were basically kazoos. The young players' blacked faces and ornate fancy dress enhance the comic effect.

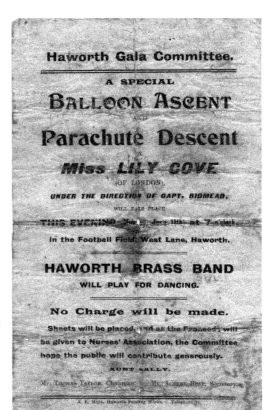

Lily Cove Balloon Ascent Handbill, 1906
The story of Lily Cove's ill-fated balloon
flight at Haworth Co-op Gala in 1906
is well known. This fragile slip of paper,
which must have been handed out in
the streets of Haworth on the day of the
flight, is an amazingly rare survival.

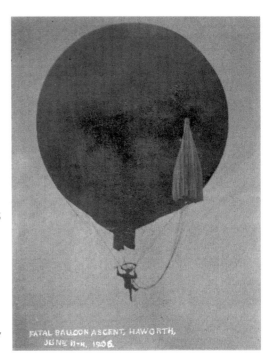

Lily Cove, the Fatal Balloon Ascent, 1906
This postcard shows Lily Cove waving to
the crowds as she ascends from the gala
field on West Lane. She sits on a trapeze
seat, is attached to the parachute by a
harness, and the top of the parachute is
lightly tied to the balloon netting. Shortly
afterwards, she jumped from the balloon
at Scar Top but somehow parted company
from the parachute and was killed.

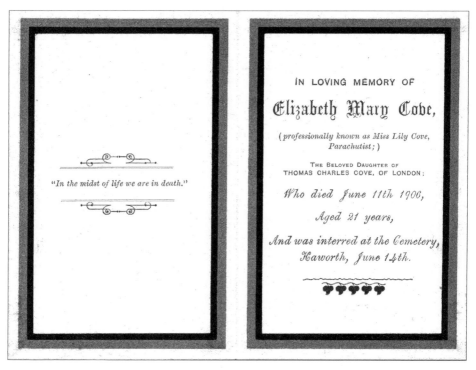

Lily Cove Funeral Card, 1906

A few years ago, this funeral card was discovered during a local house clearance. Here she is given her full name of Elizabeth Mary Cove. Her age is given as twenty-one; in fact she seems to have been only twenty years old. Lily Cove's death led to calls in Parliament for restrictions on 'performances of such dangerous exhibitions'.

Lily Cove's Grave in Haworth Cemetery, *c.* 1906

Lily Cove's body was carried to Haworth cemetery by members of the Haworth Gala Committee, led by their chairman Albert Best. A carriage followed behind with her father and her employer Captain Bidmead. This handsome headstone was erected by public subscription.

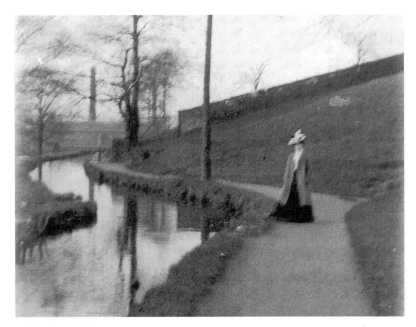

Bridgehouse Goit, *c.* 1900

The Bridgehouse Mill goit, although now dry, is still a favourite venue for gentle walks. The carefully tended goit side-path has markedly deteriorated in the last century. The elegantly clad woman in this photograph is just at the spot that is now the muddiest on the whole length of the goit.

Bridgehouse Goit, Boys Fishing, Early Twentieth Century

The goit provided other amusements than a pleasant stroll. Water always attracts small boys, and here two of them are fishing for 'tiddlers'. The Worth Valley branch railway runs across the valley bottom in the middle distance.

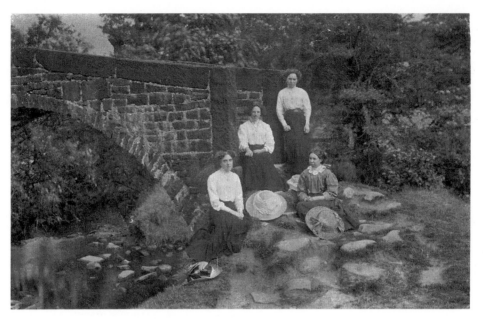

Long Bridge, Early Twentieth Century
Long Bridge spans the River Worth between Haworth and Stanbury. The descent from either side of the valley is a muddy walk today. These young women seem to have got there without muddying their ankle-length skirts.

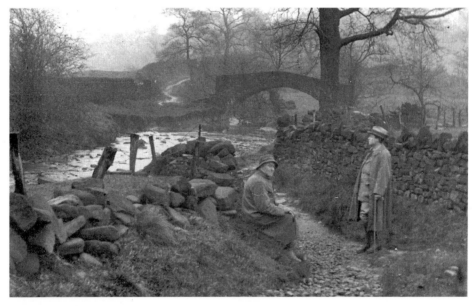

Long Bridge, Jonas Bradley, 1918
The Worth Valley can have seen few more enthusiastic walkers than Jonas Bradley. He is seen here, on the left, with a friend, on the Oakworth side of the valley at Long Bridge. This photograph was taken in the last year of the First World War, which had not managed to halt the activities of Jonas's walking group, the Haworth Ramblers.

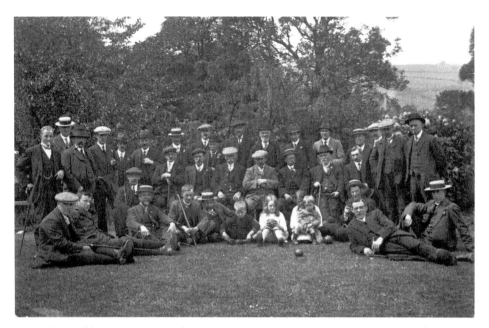

Haworth Ramblers at Horton Croft, 1914
Choice of head gear varies – flat caps, straw boaters, trilbies and the odd bowler hat. However, three-piece suits with collar and tie are worn by all the men of the Haworth Ramblers, seen here in Jonas Bradley's garden. Such dress was normal for walking at that time.

Ponden Clough Picnic Party, *c.* 1900
Ponden Clough is perhaps the most picturesque place in Haworth township. Here a Haworth party picnics at the head of the Clough. Third from left is Minnie Binns, who lived at Townend Farm. They may well have called to see Timmy Feather on their way to the moor. Minnie's mother, Mary Binns, was once given a decorative mug by Timmy.

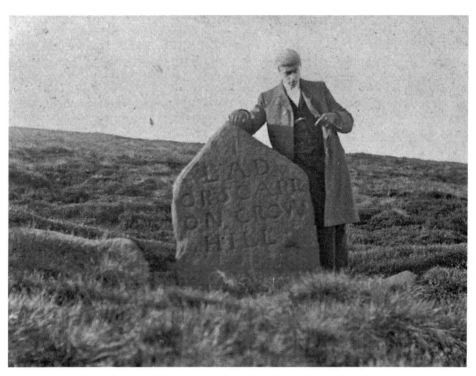

Lad of Crow Hill, Norman Birch, 1905
High up on Stanbury Moor, the Lad of Crow Hill marks the county boundary. Norman Birch, from Halifax, is photographed at the Lad by Jonas Bradley. Although the Lad is remote and surrounded by very rough moorland, access is made relatively easy by a track serving the nearby Crow Hill quarries.

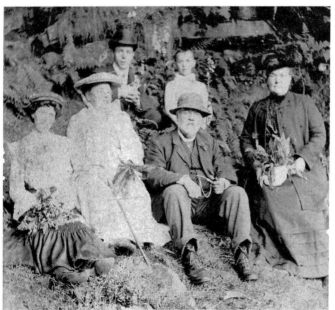

Fern Gatherers, Stanbury, 1905
The Victorians had a great craze for ferns, which were grown in terrariums or pressed and mounted in albums. Charles Kingsley believed that this 'pteridomania', as he dubbed it, was a healthier pastime for young women than 'novels, gossip, crochet and Berlin wool'. Jonas Bradley photographed this group of fern gatherers somewhere on Stanbury moor – possibly at Ponden Clough.

Withins Scar, 1912

Two of Jonas Bradley's friends are pictured here, at Withins Scar, examining the remarkable exposure of sandstones and shales. In July 1921 Bradley brought W. S. Bisat to Withins Scar to see its marine band. It was from the fossils of the marine bands that Bisat established his chronology of the Millstone Grit.

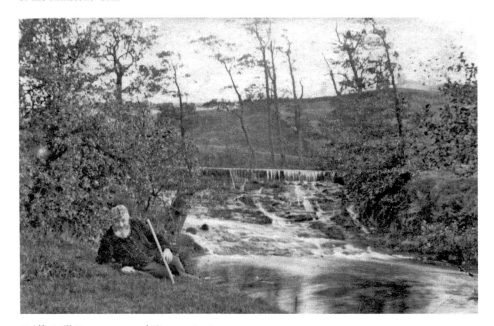

Griffe Mill Damstones and 'Spenom', 1894

Jonas Bradley's uncle, Ben Snowden, used to come over to Stanbury to go for walks with his nephew. Here he is photographed reclining by the side of the weir that diverts water into the goit leading to Griffe Mill. Back in 1859, 'Spenom', as he was known, had played a leading role in the Broughton Hall poaching affray. He features prominently in Keighley Snowden's *Web of an Old Weaver*.

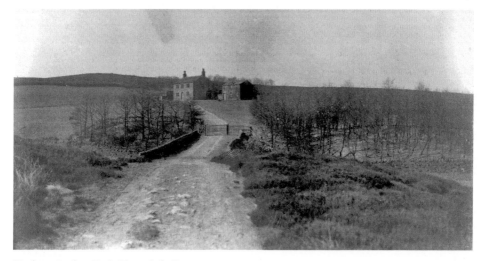

Harbour Lodge, Early Twentieth Century

The advent of the modern sporting shotgun led the owners of shooting rights to develop their estates. In 1872 W. B. Ferrand, Lord of the Manor of Haworth, built Harbour Lodge as a gamekeeper's house on Haworth Moor. This early view gives a good idea of its isolated situation at the end of a track nearly one and a half miles from the nearest road.

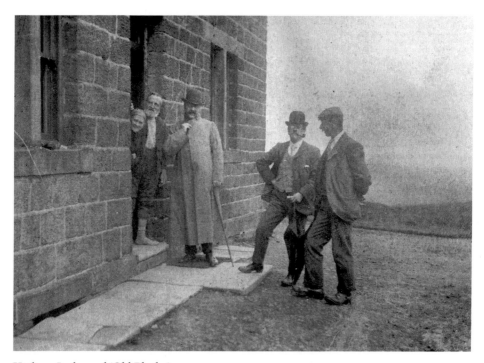

Harbour Lodge and 'Old Bluche', *c.* 1900

John Hey, or 'Old Bluche', was the keeper at Harbour Lodge for over a quarter of a century, until failing health forced him to retire. He thoroughly disapproved of Brontë-inspired visitors tramping over the moors, disturbing the grouse. He refused to believe that 'little Charlotte o' th' parsonage' could have written any books – 'she just gat some cleverish sort o' chap to write 'em for her.'

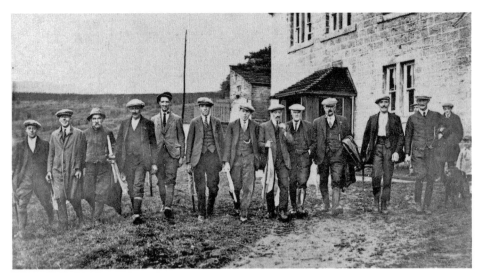

Harbour Lodge, Beaters and Keepers, *c.* 1930
Shooting parties were still visiting Haworth Moor in the 1930s, long after 'Old Bluche' had died.
Here is a party of beaters and gamekeepers at Harbour Lodge around 1930. On the right of the
main group are Joseph Heaton and Arthur Hopkinson.

'Tubber' with Gun, Leeming, Early Twentieth Century
It was not only the gentry on the grouse moors who enjoyed shooting. This is William Whitaker,
of Oxenhope, posing with his gun. His nickname, 'Tubber' or 'Billy Tubber', tells us that he
worked as a night soil man. The gun is a single-barrelled, percussion-system breech-loader dating
from the late 1850s.

Boys Shooting at Leeming Reservoir, Early Twentieth Century
Boys also liked shooting. These two lads, on a footbridge at Leeming Reservoir, enjoyed more freedom in this respect than would be normal for youngsters today.

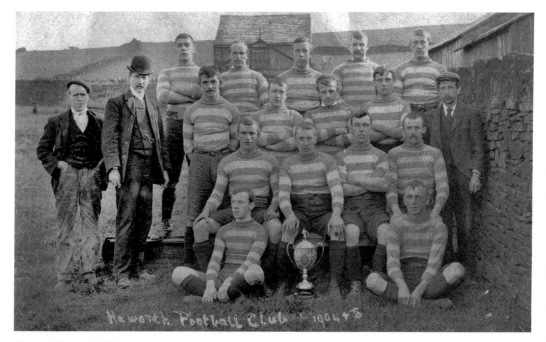

Haworth Football Club, 1904/05
The Haworth area also supported many football and cricket clubs over the years. This picture shows one of Haworth's rugby football clubs posing with the Keighley Charity Cup, which they had won the previous season. They were based at the ground on West Lane, which is now used for cricket. Where this photograph was taken is uncertain.

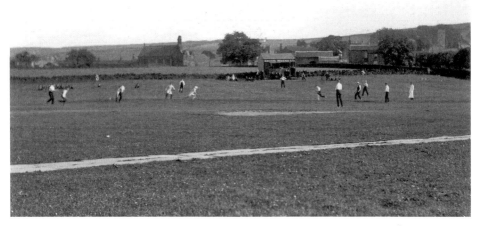

Oxenhope Wesleyan Cricket Club, Mid-Twentieth Century
Like many things, sport was organised on sectarian lines in the Worth Valley. Methodists, Baptists and Anglicans all had their own cricket teams and they played in different leagues. It is unusual to have photographs of teams actually playing cricket rather than posing with their trophies. Here the Wesleyans are playing on the recreation ground at Uppertown.

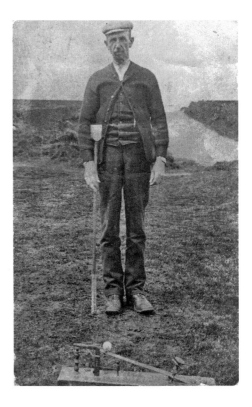

Albert Normington, Knurr and Spell Player, 1910
Knurr and Spell is little remembered now, but used to be very popular in this area. The trap in the foreground was used to propel a small pot ball into the air. The player struck it with his stick and tried to drive the ball as far as possible. The moors were an obvious venue for this game – especially when illegal gambling was involved.

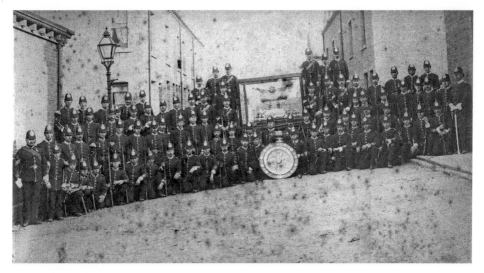

Haworth Rifle Volunteers on Minnie Street, Late Nineteenth Century
The 42nd Company of Rifle Volunteers (West Yorks) was formed in Haworth in 1866 with George Merrall as captain. Despite a rather shaky start, they were soon winning awards for drill and shooting. They are seen here on Minnie Street, outside the Drill Hall, with some of their trophies.

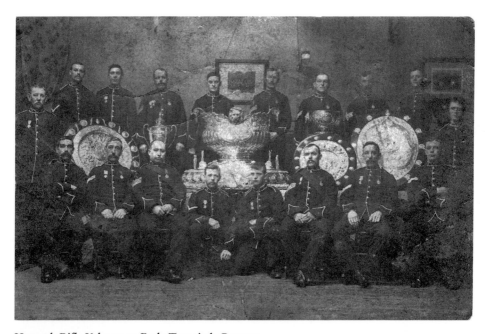

Haworth Rifle Volunteers, Early Twentieth Century
The Volunteers pose with their trophies inside the Drill Hall. The money for this Drill Hall was raised by a bazaar held in April 1870. There were fancy needlework stalls from Haworth, Oxenhope and Oakworth, and a refreshment stall. After some initial difficulties, a site was acquired and the Drill Hall opened in 1873.

Sergeant Boyes' Son in Silver Trophy, Early Twentieth Century

The sheer size of the silver trophy seen in the previous two pictures is demonstrated here by the young son of Colour Sergeant William Boyes. The Haworth Rifle Volunteers at this time had one captain, one surgeon lieutenant, one sergeant-instructor, seven sergeants, four corporals, two buglers and ninety privates.

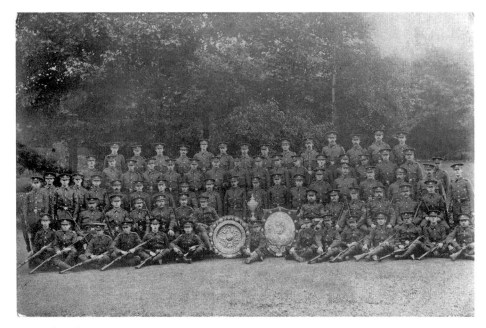

Haworth Volunteers, 1907

The Volunteers, a few years later, are now dressed in the sort of uniform in which many of them would all too soon be serving in the First World War. Between 1889 and 1897, they had won the Arnold Foster Drill Shield (*left*) five times. In the year that this picture was taken, they had won the New Drill Shield (*right*) for the fourth time. They had won the Battalion cup three times.

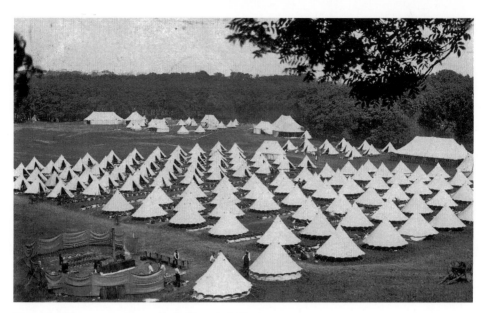

Haworth Volunteers at Camp, Early Twentieth Century
The Volunteers had annual camps under the direction of a colonel. The site of the camp in this photograph is unfortunately unknown. The men appear to be laying out their kit for inspection. There is a field kitchen in the bottom left corner of the picture.

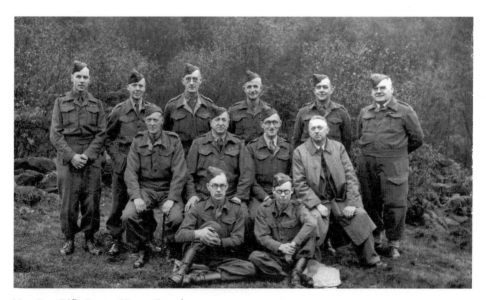

Nan Scar Rifle Range, Home Guard, 1944
The Volunteers' first rifle range was opened on Black Moor in 1867. By 1888 they were at their new range at Nan Scar near Leeming reservoir. This rifle range was used by the Home Guard during the Second World War. Here are the officers of the Oxenhope Home Guard at Nan Scar on their Officers' Field Day in 1944. Front left is 2nd Lieutenant Smith Midgley, later to be Lord Mayor of Bradford.